Sculpture

Page 4:
Portrait of a Woman
marble, flavones period
Capitoline Museums, Rome

Designed by :
Baseline Co Ltd
127-129A Nguyen Hue
Fiditourist 3rd Floor
District 1, Ho Chi Minh City
Vietnam

ISBN 978-1-84013-744-6

Published in 2007 by Grange Books
an imprint of Grange Books Plc
The Grange Kingsnorth Industrial Estate
Hoo, nr Rochester, Kent ME3 9ND
www.grangebooks.co.uk

Printed in China

Foreword

"It is truly flesh! You would think it moulded by kisses and caresses! You almost expect, when you touch this body, to find it warm."

– Michelangelo

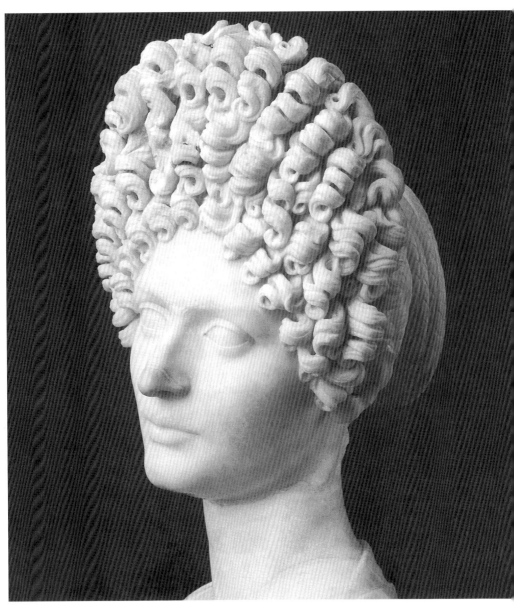

Contents

Barthé, Richmond 220

Bernini 134, 136

Brancusi, Constantin 216

Burgos 104

Canova, Antonio 148, 150

Carpeaux, Jean-Baptiste 156

Cellini, Benvenuto 130

César 236

Coysevox, Antoine 142

Degas, Edgar 186

Della Robbia, Luca 94, 102

Donatello 92, 96, 98, 100

Dubuffet, Jean 244

Erhart, Michel and Grégor 108

Gabo, Naum 214

Gauguin, Paul 182, 184, 194

Giacometti, Alberto 230

Girardon, François 138

Rodin

Degas

modigliani

Hosmer, Harriet	154
Kirchner, Ernst Ludwig	200
Matisse, Henri	190
Michelangelo	106, 110, 112, 114, 116, 118, 120, 122, 126, 128, 132
Modigliani, Amedeo	202, 208, 210
Moore, Henry	224, 246
Nauman, Bruce	242
Oppenheim, Meret	222
Picasso, Pablo	212, 226, 228, 232
Puget, Pierre	140
Rauschenberg, Robert	234
Regnaudin, Thomas	138
Rodin, Auguste	158, 160, 162, 164, 166, 168, 170, 172, 174, 176, 178, 180, 188, 198
Saint-Phalle, Niki de	240
Torrigiani, Pietro	124

S culpture, although it preceded painted art, was long considered to be merely the accessory and complement of the eldest of the three arts: architecture. Executed using the same materials as in architecture – wood, stone and marble – sculpture was initially seen as ornament for architecture.

The Brassempouy Lady, Grotte du Pape

Circa 22000 B.C.
Ivory, height 3 cm
Museum of National Antiques
Saint-Germain-en-Laye

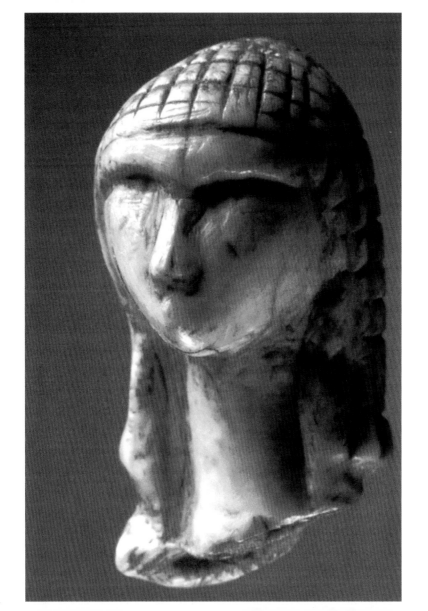

9

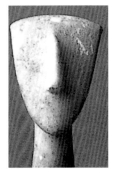

However, little by little, sculpture soon established itself as an independent and dignified art. After having admired the universe, man started to contemplate himself. He recognised that the human body is among all forms the only one able to fully manifest the spirit and aspirations of man.

Idol

———

Cyclade Islands, Greece, 2700-2400 B.C
marble
The Menil Collection, Houston

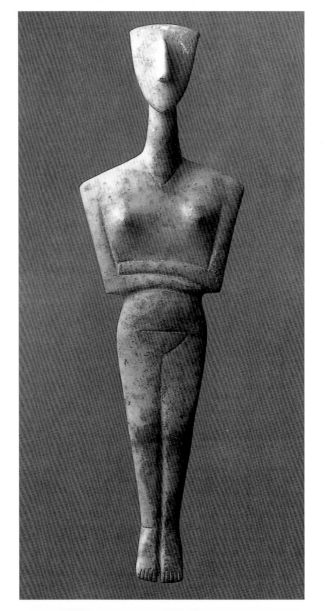

Ruled by proportion and symmetry, superior in beauty, sculptors would work hard to reinvent the perfect body. Likewise, in the slow path of progress that led painting to produce what we call a work of art, it was a long process for sculpture to detach itself from architecture and produce what we call low-relief and sculpture in the round.

Sitting Writer

ca. 2510-2460 B.C.
multicoloured stone, height 53 cm
The Louvre, Paris

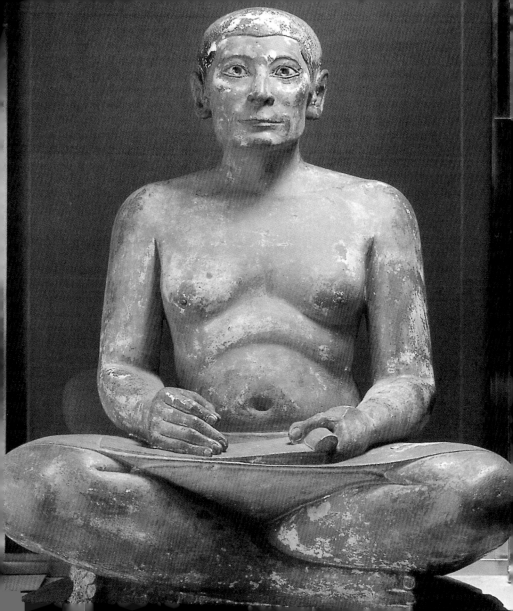

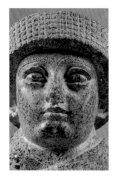

It is in the depths of antique and primitive civilisation in the Nile Basin that one must search for the origins of the arts. Around the same time that the Nile settlers constructed temples and pyramids, they engraved headstones and tombstones and lined the avenues leading up to their temples with sphinxes mounted on pedestals.

Votive Statue of Gudea

Mesapotamia, ca. 2120 B.C.
Diorite, height 73.7 cm
The Louvre, Paris

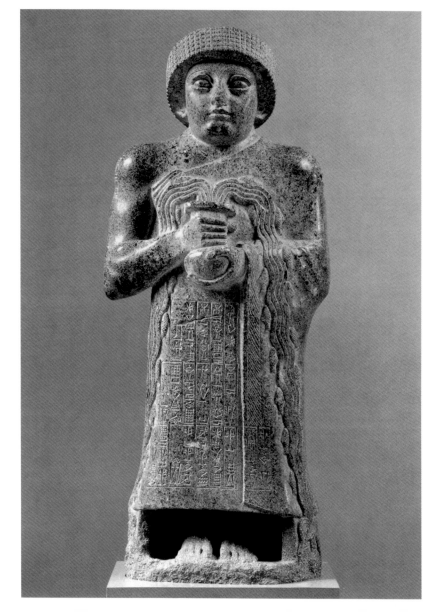

15

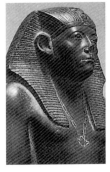

Rivals to the Egyptians, the Assyrians certainly had more influence over the Greek and the Etruscan civilisations. The oldest monuments from Greece and Etruria show evidence that they somewhat imitated ancient Assyrian art. We can witness this from Cyprus to Rhodes, from Crete to Sicily, from Athens to Corinthia.

Sesostris III

Dynasty 12, ca. 1878-1842 B.C
black granite, height 54.8 cm
The Brooklyn Museum

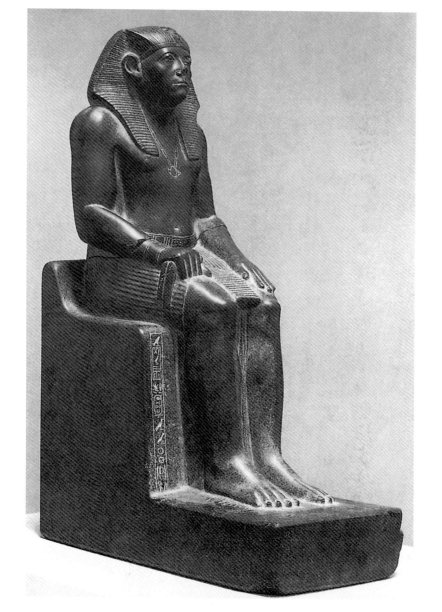

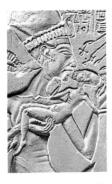

Etruria can be proud of an ancient primitive civilisation which was close to our own. Originated with Asian influences, it modified the Greek civilisation, then the Roman, by bringing to them the first rudiments of all arts and industries.

Akhenaten and his Family

ca. 1348-1336 B.C.
low relief of multicoloured stone, 31.1 x 38.7 cm
National Museums of Berlin

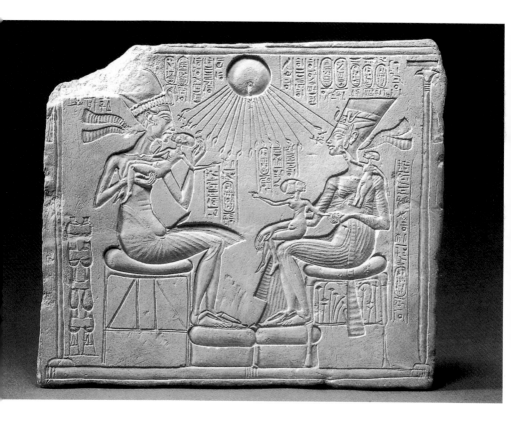

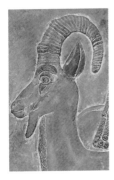

Greek sculpture

What Pliny said about painting, "de picturae imitis inserta," can also be said about sculpture. One can be certain that Greek art started out by imitating Oriental art. However, contrary to other ancient civilisations, the Greeks only followed lessons as a means to react against their masters.

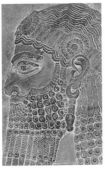

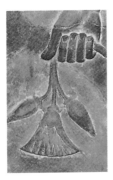

Ibex Porter
——————
Assyrian Empire, 8th century B.C.
alabastrite low relief, height 2.68 m
The Louvre, Paris

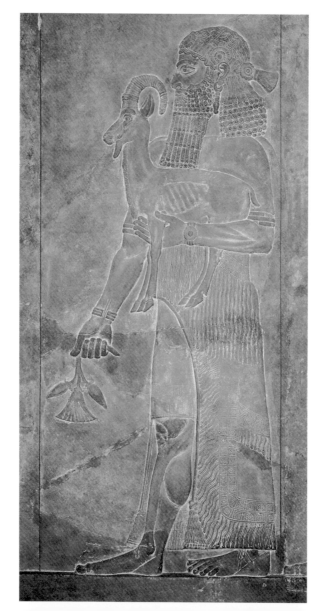

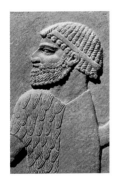

If they did not invent art, they did invent beauty. *Aphrodite of Melos* (The Louvre Museum, 2nd century BC) may be the most magnificent specimen of Greek art. She is marvelously composed — the curves of her torso, the fineness of her skin — and she is the perfect equation between the subject and the style.

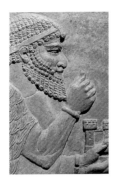

Tribute procession of the Medes

Assyrian Empire, 8th century B.C.
alabastrite low relief, height 1.62 m
The Louvre, Paris

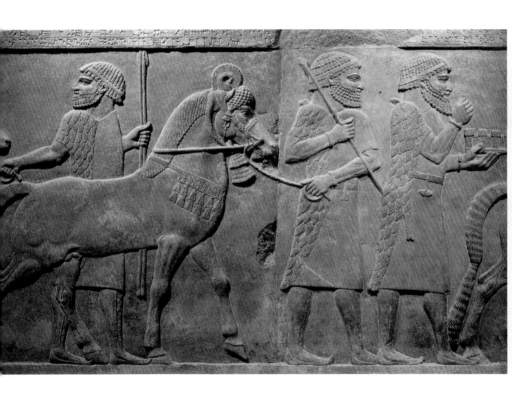

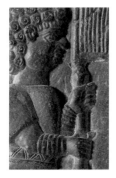

The Aphrodite of Melos, like other Gods and Goddesses, demonstrates the useful influence that mythology had on the arts. In believing that man had been made in the image of Gods and that Gods had all the passions of men, that is, in creating Gods in their image, the Greeks tried to recreate the most perfect forms to represent divinities in a worthy manner:

Spinning Woman
———————
Iran, 8th or 7th century B.C.
Bitume, low relief, 9.2 x 13 cm
The Louvre, Paris

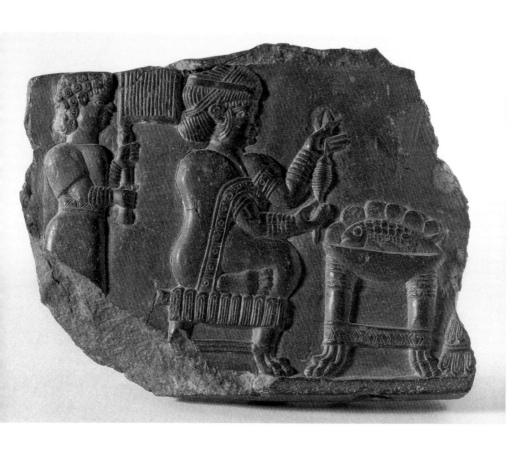

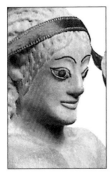

model, prototype, apotheosis of humanity. We should not forget that the old Greek idols had not only been painted but were also dressed and had servants, priests and wives. They were, according to Ottfried Miller, washed, waxed, scrubbed, dressed and adorned with crowns as well as jewelry.

Aryballos. Vase in the Form of a Kneeling Athlete

580 B.C.
Museum of the Agora of Athens

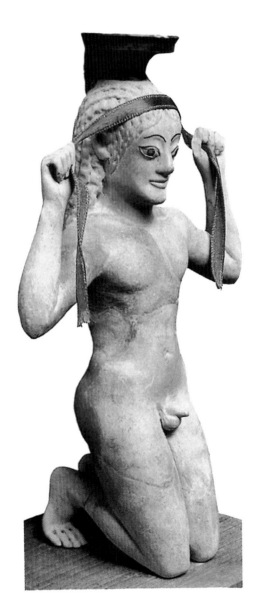

Roman sculpture

Vanquished and conquered by Rome, Greece was reduced to the state of a simple province of the Republic and later the Roman Empire. It remained nonetheless a strong cultural model for Rome. Cicero, Pliny and Quintilien have brought us the names of all the important Greek sculptors;

Hera of Samos
—————————

middle of the 6th century B.C.
marble
The Louvre, Paris

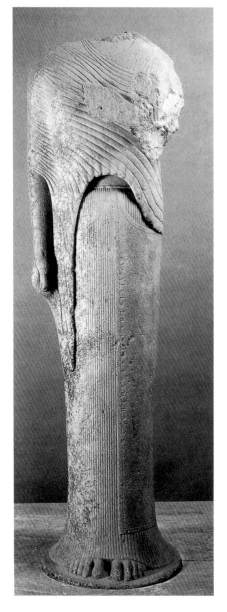

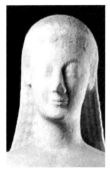

and yet they do not once quote a single Roman sculptor. So, the Romans themselves or the Greeks who came to Rome would scarcely make any other works than those depicting Caesar, the impure wives of their Emperors, the favourites of the imperial Palace.

Kouros from Anavyssos

550 B.C.
marble, height 2.14 m
National Museum, Athens

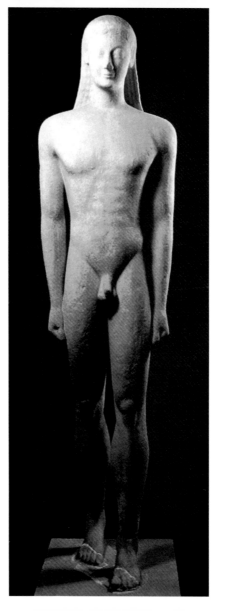

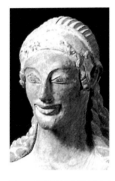

Art was industrialised, and pre-fabricated statues of emperors were produced to which they adapted heads according to their needs. After enriching itself with the spoils of the world, Rome fell for opulence and bad taste, preferring precious metals over simple art materials and richness over beauty.

Apollo in the Temple of
Portanaccio of Véies

510 B.C
sandstone
Villa Giulia National Museum, Rome

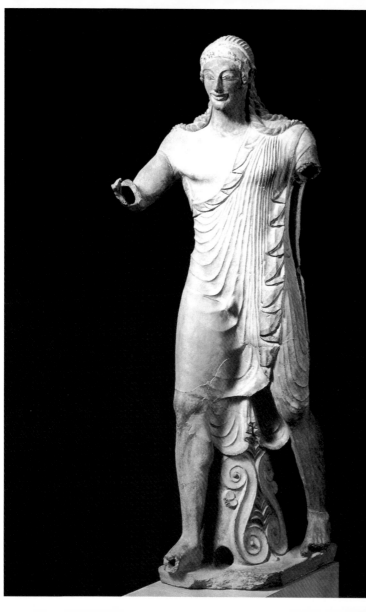

33

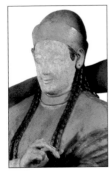

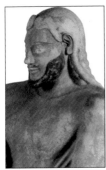

When Constantine transferred the seat of the new empire to Byzantium, he brought with him the gods and the heroes of paganism, converting Roman basilicas into churches. The first Christians showed a certain ignorance and deep antipathy towards the fine arts and started to destroy all the vestiges of Antiquity and the ancient world.

The Man and Wife Sarcophagus

Etruria, end of 6th century B.C.
terracotta, height 114 cm
The Louvre, Paris

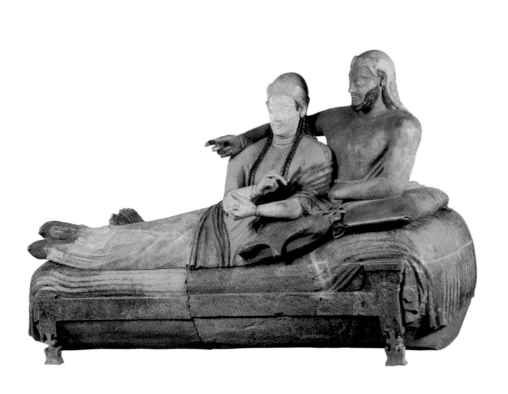

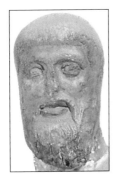

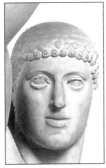

Italian sculpture

In 13th century Tuscany, an artistic renovation movement began that would bring sweeping changes to the art of sculpture. Nicolas de Pise was at the head of this movement, followed by his son Giovanni, his student Arnolfo, Agnolo di Ventura of Sienna, and later Donatello, Della Robbia and Michelangelo.

Harmodius and Aristogiton
The Tyrannicides

477 B.C
marble copy of a Greek original in bronze
National Archaeological Museum, Naples

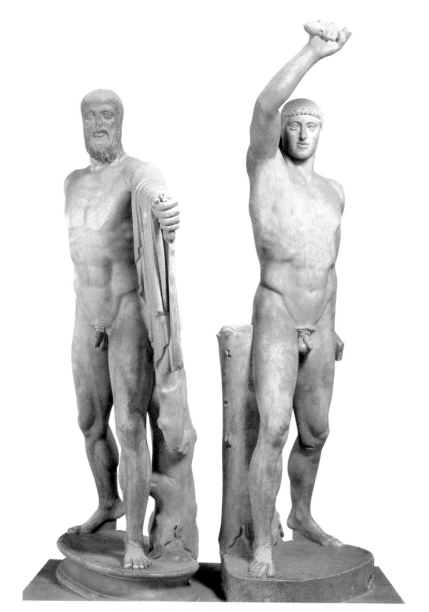

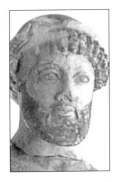

Born in Florence in 1474, Michelangelo Buonarroti would often start work on a block of marble without any preparation, without any sketches, and without any models. He would sometimes run out of marble, or would sometimes cut the marble too deeply, which stopped him in his creation, leaving the block of marble only roughly worked.

Zeus and Ganymede

470 B.C.
marble and polychrome sandstone
Archaeological Museum, Ferrara

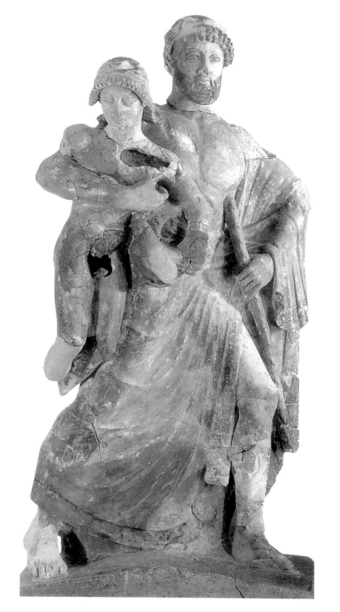

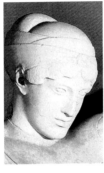

However, none would complain as such work, like with any artist's sketches, offers a look at the early thoughts and inspiration of the artist. His finished works offered an extraordinary perfection, such as the delicate forms found in *Bacchus* (1496-1497). About the same time that Michelangelo was living in Florence,

West Pediment of Zeus Temple
in Olympia, centaur raping Déidamia

460 B.C.
marble
Museum of Archaeology, Olympia

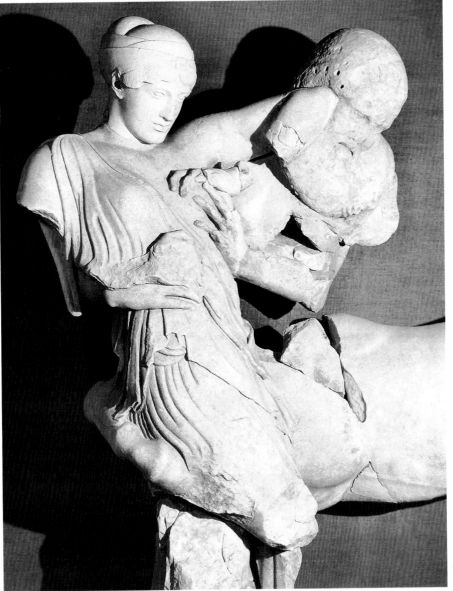

and Sansovino in Venice, another Florentine, named Benvenuto Cellini (1500-1570), left Italy to work in Fontainebleau, just outside of Paris. There he met another italian Gian Lorenzo Bernini from Naples. Lorenzo was an architect and artist credited with starting the Baroque style of sculpture. He was named 'the second Michelangelo' and it was he who came to be asked by Louis XIV to help to restore the Louvre.

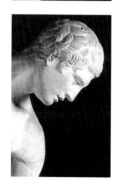

Two Discus Throwers

Myron, ca. 450 B.C
Vatican Museums, Rome

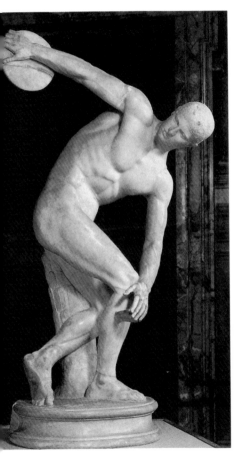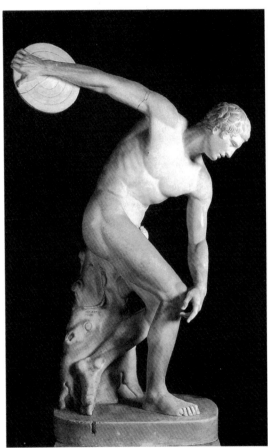

It was Antonio Canova (1757-1822) who continued the line of impressive sculptors. His figures were apparently so realistic that he was accused of making plaster casts from live models. Among his most important commissions were the tombs of two popes, Clement XIII and Clement XIV.

Metope from the Selinonte Temple
The Acteon's Punishment

Sicily, ca. 450 B.C.
Archaeological Museum, Palermo

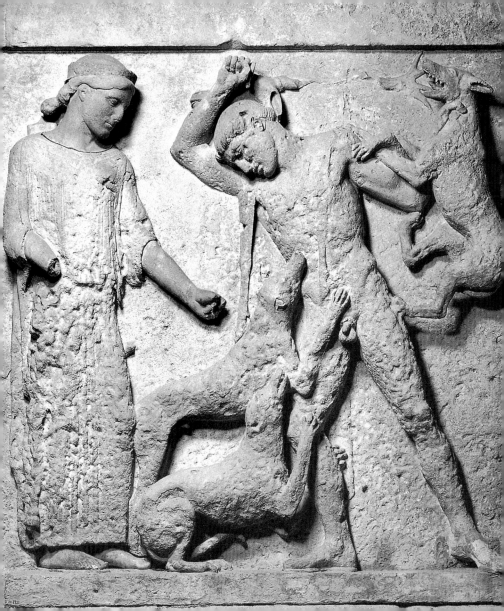

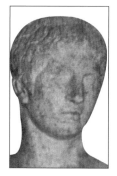

In 1802 he became court sculptor to Napoleon I in Paris. He dominated European sculpture around the turn of the century and was of primary importance in the development of the neoclassical style in sculpture. He was not, however, a disciple of Michelangelo's!

Doryphorus (Spear-Carrier)

Polykleitos, 440 B.C
marble copy of a Greek original in bronze, height 2.12 m
National Archaeological Museum, Naples

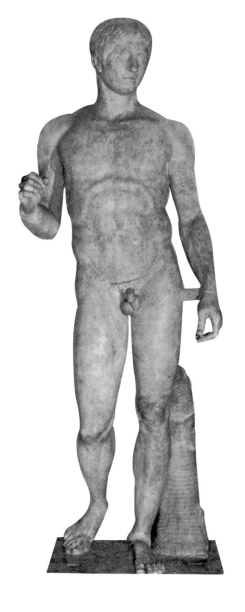

Spanish sculpture

Sculpture in Spain was never as highly regarded as painting. One can hardly find any clue to its existence as Spanish sculpture could never rival the magnificent paintings of Velásquez, Murrilo or Ribera. The Arabs taught the Spanish much about architecture since the Koran speaks against other arts.

Victory Fastening Her Sandal

407-410
marble, height 1.07 m
Acropolis Museum, Athens

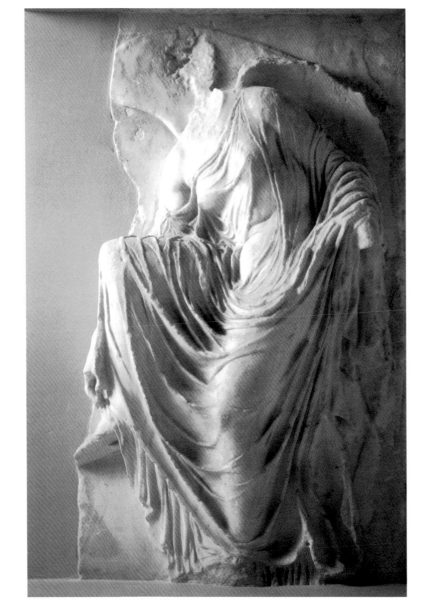

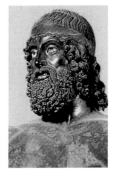

It was two foreigners, Florentine Guerardo Starina and Flemish Pierre de Champagne, that would later bring over examples of more impressive sculpture. A disciple of Michelangelo's, Torrigiano (1472-1528) fled Florence, became a soldier and won the right to teach. He returned to art traveling between Flanders, England, and then Spain.

Statue from Riace

5th century B.C.
bronze, classical epoque, height 1.96 m
National Archaeological Museum, Reggio Calabria

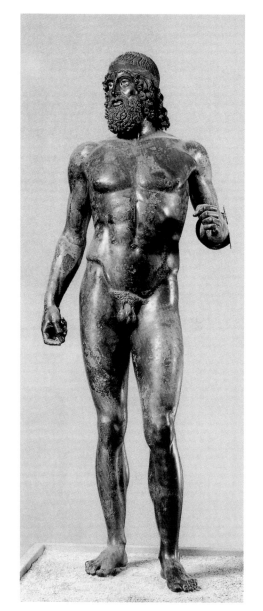

In 1520, he built a terra-cotta statue of Saint Jerome in the convent of Buenavista, near Seville, which Goya considered better than the Moses by Michelangelo. Amongst the Spanish artists who went to Italy under the reign of Ferdinand of Aragon and of Charles V to take art lessons, there were only two who mastered all three arts:

Pan teaching the Flute to Olympos

350 B.C
marble
National Archaeological Museum, Reggio Calabria

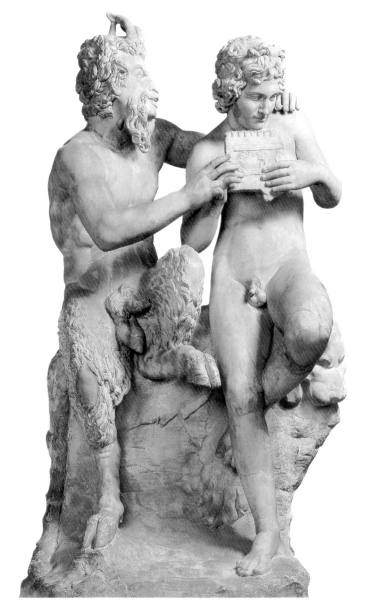

53

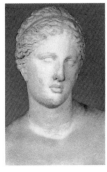

Alonzo Berruguete (1488-1561) and Gaspar Becerra (1520-1570). In 1635, Alonzo Cano (1601-1667), worked on the altarpiece in the church of Lebriya, one of the most beautiful works of its kind, where one can admire his statue of the Virgin Mary.

Aphrodite of Cnidos

Praxiteles, 350 B.C.
Roman copy of a Greek original
marble, height 2.3 m
Vatican Museums, Rome

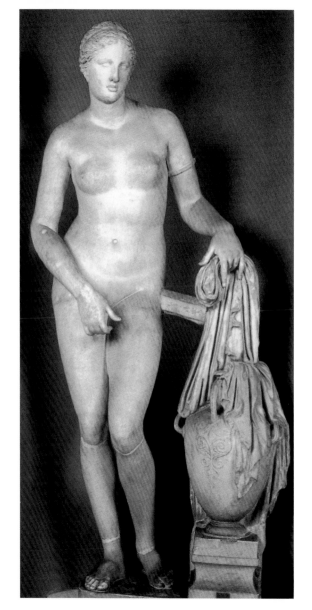

He is often called the 'Spanish Michelangelo' because of the diversity of his talents. With him the art of sculpture in Spain ended. The universal exhibitions were held thereafter without exhibiting one single example of Spanish sculpture.

Apoxyomenos

———————

Lysippus, 330 B.C.
Roman copy of a Greek original
marble, height 2.6 m
Vatican Museums, Rome

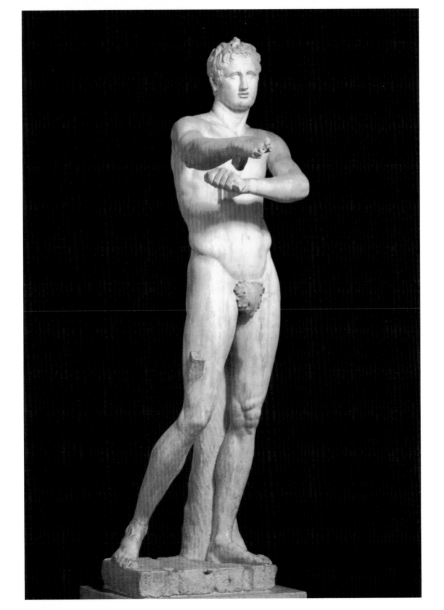

German sculpture

Like Spain, Medieval Germany did little to cultivate the art of sculpture. During this period it seems that not one artist came from Germany. It was however different during the Renaissance period when numerous German sculptors were in demand in Italy and these

Hermes with Sandal

related to Lysippus or his school
End of the III century B.C.
Roman copy of a Greek original
marble, height 154 cm
The Louvre, Paris

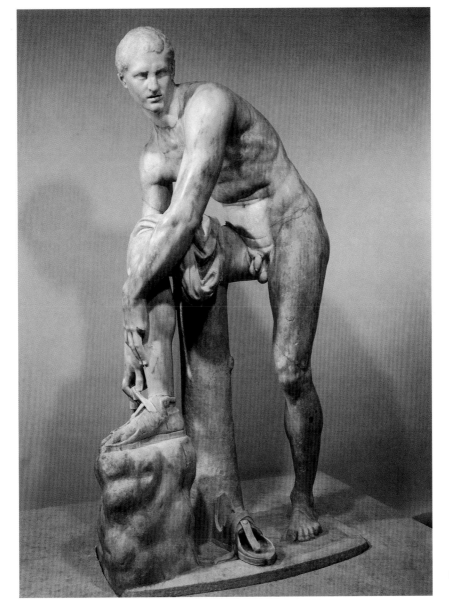

59

modest and simple artisans did not attach great importance to signing their work. We later discovered that the beautiful fountain in Nuremberg is by Sebald Schuffer and that the long low-reliefs of the *Passion* are by Hans Decker and Adam Kraft (c.1455-1509).

Head attributed to Brutus the Old

225 B.C
bronze
Capitoline Museums, Rome

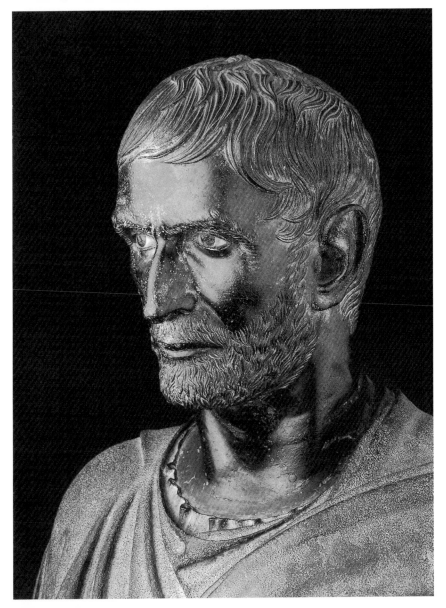

61

During the period of the three German schools of paintings, Nuremberg, Augsburg and Dresden, which was personified by Holbein and Ganach, there were almost no artists capable of rivaling them apart from the great Renaissance artist of Northern Europe, Albrecht Dürer (1471-1528), who sculpted wood and ivory.

Barberini Faun

———————

Hellenistic period, ca. 200 B.C.
marble copy of a Greek original in bronze, height 2.15 m
The State Antique Collection, Munich

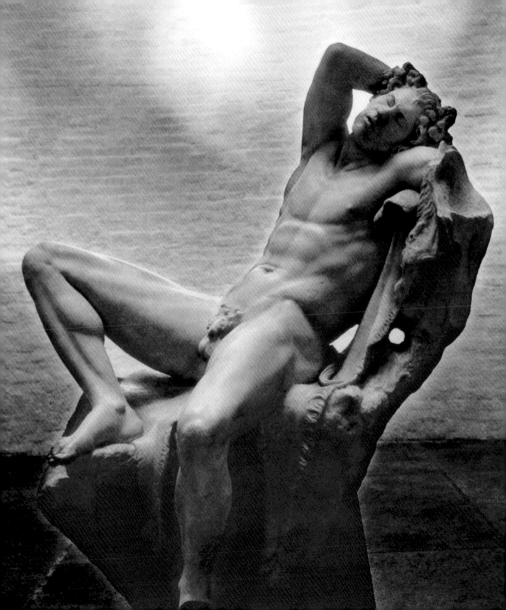

The protestant religion, less sumptuous than the Catholic religion, would curb art works being produced in Germany whilst the horrible thirty-year war would bring along ruin and destruction. It was only during the Renaissance of the early 19th century that Germany produced great works again from Owerbeck (1789-1869), Cornelius, Dannecker (1758-1841) and Joseph Kaeshmann.

Venus of Melos

ca. 100 B.C.
marble, height 2 m
The Louvre, Paris

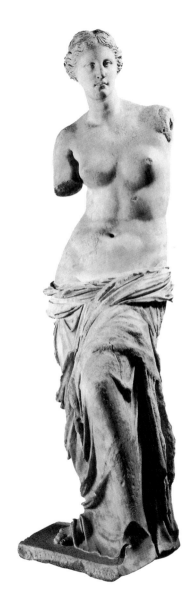

Christian Ranch (1777-1857) would open a studio in Berlin and found an art school. The work of art which made him well-known in Germany is the mausoleum of Queen Louise in Charlottenburg. The Saxon Ernest Rietschel (1804-1861) led the sculpture movement in Germany thereafter.

The Big Cameo of France

ca. 23 B.C.
sardonyx, 32 x 26.5 cm
Bibliothèque nationale de France, Paris

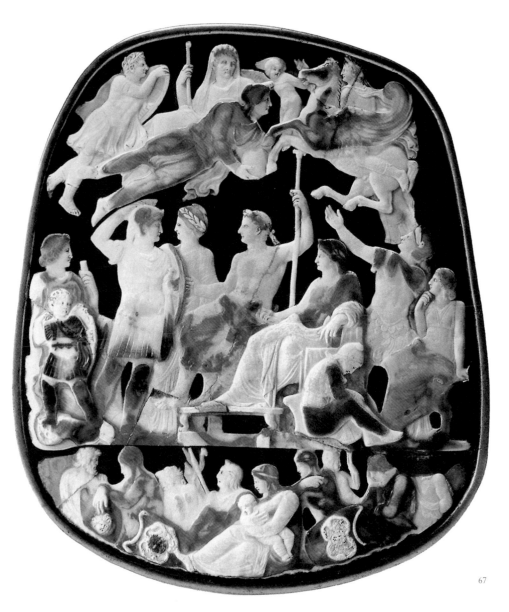

Flemish sculpture

In Flanders, like in Holland, the art of sculpture never really flourished. The country, having no marble quarries, copper mines, or stone and importing its wood from other countries, seemed to have rejected an art for which it could not provide any raw material. It is only in Bruges that we can find examples of Flemish sculpture.

Ajax and Patroklos

125-150 B.C.
Roman copy of a Greek original
marble
Loggia dei Lanzi, Florence

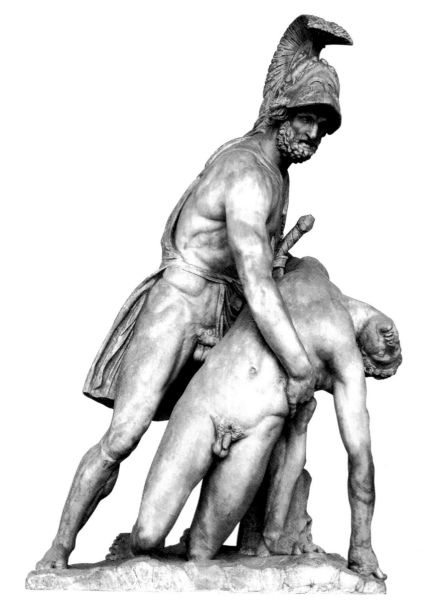

69

English sculpture

The English cultivated, up to the 19th century, a real taste for and success in secondary genres in art: watercolour, keepsakes and painted or engraved portraits (rather than the bust used in sculpture). It is in king Henry VII's chapel in Westminster where the oldest and perhaps the most beautiful example of English sculpture can be found.

Ara Pacis Augustae: The Procession

10 B.C
marble
Rome

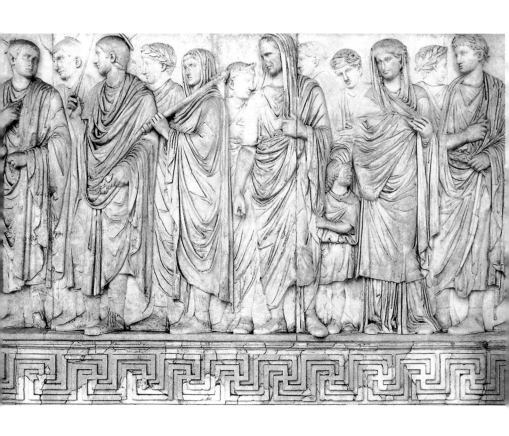

In this chapel, every man who has contributed to the safety of the nation shares the privilege of being buried there with the king. English sculpture saw some of its most beautiful creations appear around the beginning of the 20th century.

Antinous

ca. 130 A.D
marble from Paros
Archaeological Museum, Delphi

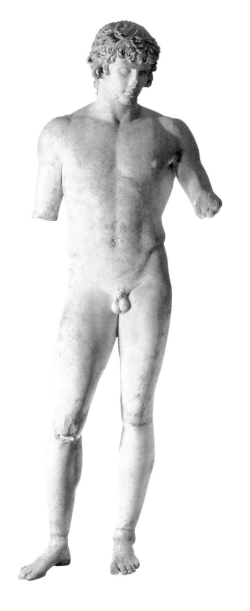

French sculpture

In France, the 14th century onwards saw sculpture and stained glass art flourish through the imitations of Byzantine paintings in religious edifices. In Paris, the monks at Cluny employed stone masons and the most capable

Personification of the Nile

marble
Vatican Museums, Rome

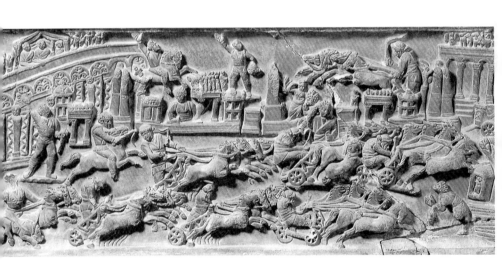

of these artisans were put in charge of carving the sculptures. However, these artisans remained anonymous and could not rival the great names of sculpture. The figures they created lacked movement and beauty.

The Belvedere Apollo

ca. 140 B.C.
marble copy of a Greek original in bronze
Museo Pio Clementino, Vatican

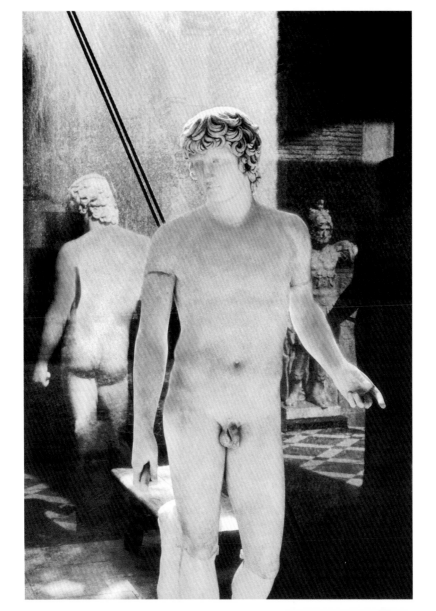

Pope Gregory VII condemned all practice of the arts and the Church was hostile to beauty and to form. They demanded that works represent the saints, displaying only austerity and virtue and bearing nothing that would "trouble the eyes or the senses" or inspire any kind of terrestrial love.

Portrait of a Woman

marble
Capitoline Museums, Rome

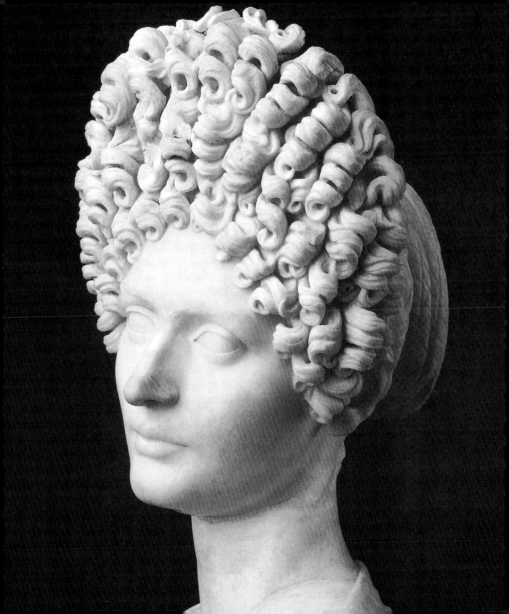

The sculptors were condemned to only produce sculptures with facial grimaces and contortions, scorched by the flames of Hell. From the 12th century onwards, art became less and less religious as artists learned the laws of proportions, perspective and more importantly, the laws of using light to colour the sculptures.

Diana the Hunter

1st-2nd century A.D
marble, height 2 m
The Louvre, Paris

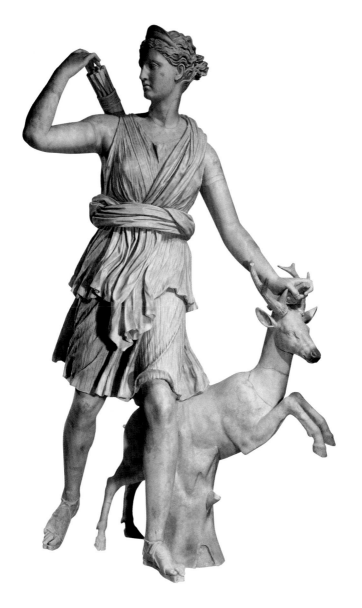

Sculpture was still part of architecture and considered primarily ornamental. At the same time that the Italians brought to France great examples of sculpture, the Frenchman Jean de Boulogne (1529-1608) went to Italy to exercise his talent as a sculptor.

The Deposition

1225
teinted wood
Santa Maria Assunta Cathedral, Volterra

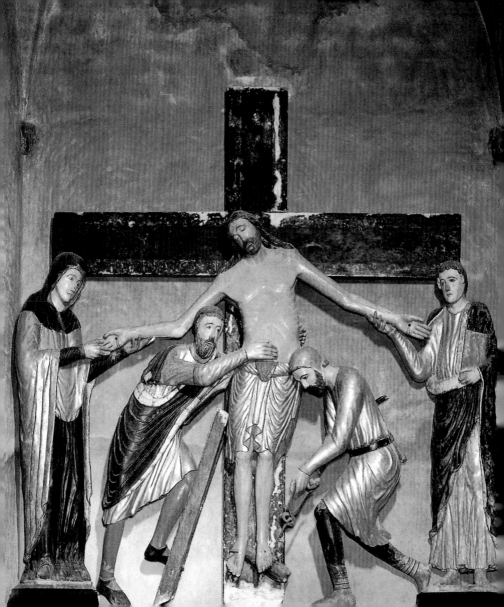

Jean Goujon (1510-1565), another very important craftsman in the history of French sculpture, shared his fame with two more: Jean Cousin and Germain Pilon. The latter's work represents a transitional link between the Gothic tradition and Baroque sculpture.

Prophet Isiah

middle of 12th century
Sainte-Marie Abbey, Souillac

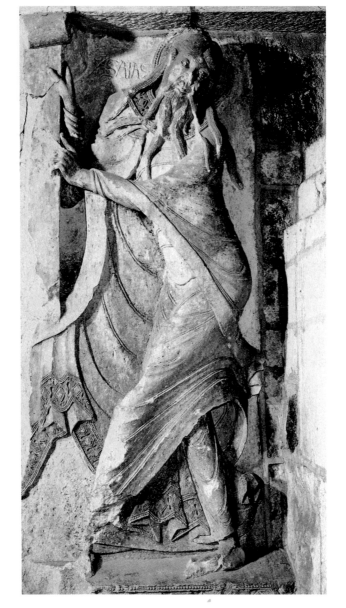

His most famous works include funerary sculptures for Henry II and Catherine de Medici in St Denis (1561-1570). Pierre Puget (1622-1694) deserves the nicknames "Rubens of sculpture" and "French Michelangelo." He had similar creative genius to Michelangelo

Jesus and Saint John the Beloved

ca. 1300
Sculpture on painted and gilded wood
Bayerisches National Museum, Munich

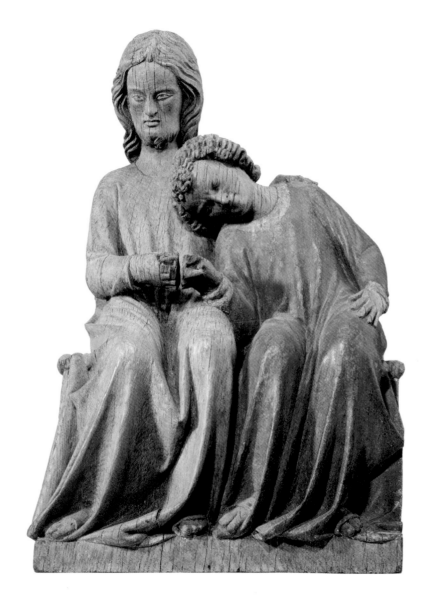

and often started on a block of stone without any preliminary studies. Many of his sculptures can be seen in the Palace of Versailles, including his marble piece *Perseus and Andromeda*. From the 18th century, let us not forget Jean-Baptiste Pigalle (1714-1785),

Jesus and Saint John the Beloved

Circa 1300
painted and gilded wood sculpture
Staatliche Museen Preußischer Kulturbesitz, Berlin

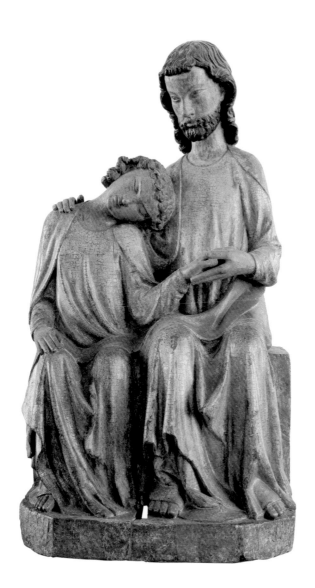

an artist who preferred the real to the beautiful and whose name is more associated with the debauchery of Paris than to his œuvre. Jean-Antoine Houdon (1741-1828), showed how the real could be juxtaposed over the ideal and how the body is animated by the spirit.

Virgin with a Child

Donated by Queen Jeanne d'Evreux
to the Abbey of Saint Denis in 1339
golden silver, gold, stones
The Louvre, Paris

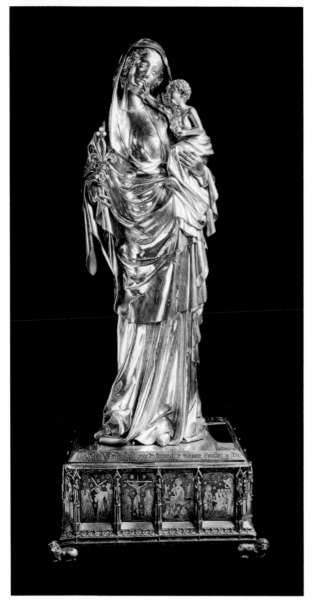

91

The 20th century

The 20th century saw the art of sculpture evolve to maturity, freeing itself from all religious or academic constraints. New forms and new materials appeared with innovative liberty, and revolution in concepts.

David

———

Donatello, 1440-1443
bronze, 158 cm
National Museum, Florence

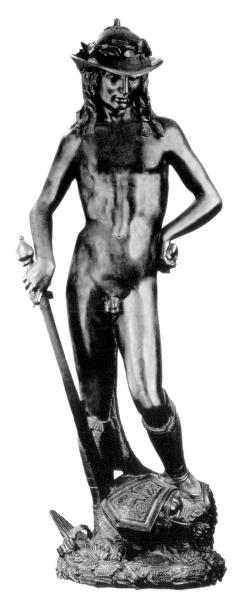

It is the century of Dalí, Calder, Moore, Giacometti, Brancusi, César, and Buren among others. Sculpture is not considered an ornament for architecture anymore. Its aesthetic potential has become one of the most important elements in the work of the architect or the urban planner.

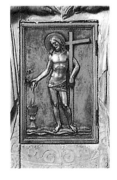

Tabernacle

Luca Della Robbia, 1441-1443
marble and polychrome sandstone
Santa Maria, Peretola

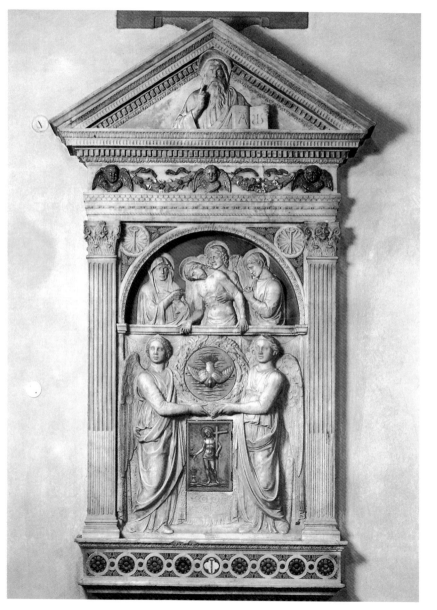

Sculpture embraces varied techniques such as modeling, carving, and casting. While modeling is a highly flexible technique that allows the artist to add or subtract material from the sculpture, carving is a technique that only allows for materials to be removed from an original block.

The Virgin between Saint Francis and Saint Anthony, main altar

Donatello, 1448
bronze, 159 cm
Padua

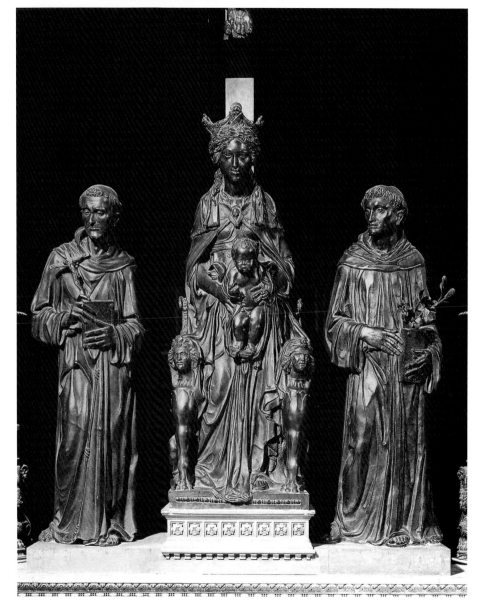

Carvers had therefore sometimes recourse to adding pieces of sculpture together. Casting is a reproduction technique that duplicates the form of an original sculpture whether modeled or carved and allows for infinite reproductions.

Mary Magdalene

Donatello, 1455
polychrome wood, 188 cm
Baptistery, Florence

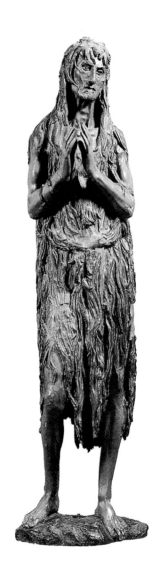

Sculpting techniques like hand modeling in wax, papier-mâché and clay have, throughout the ages, evolved very little except for the process of firing clay from terra-cotta to elaborately glazed ceramics.

The Holy Women at the Tomb

Donatello, 1465
bronze
San Lorenzo, Florence

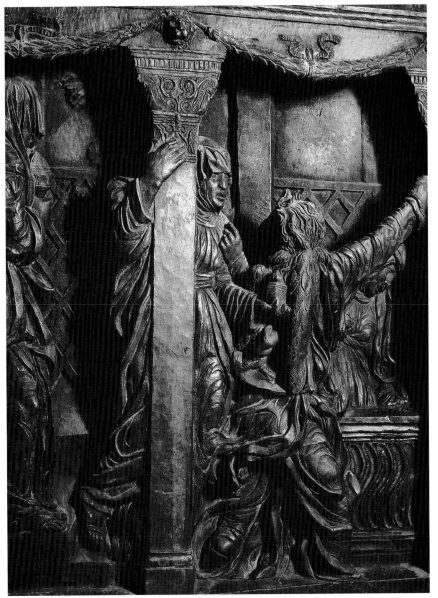

Carving has for centuries used the same materials: stone, wood, bone and more recently plastic, and the same tools: hammers, chisels, drills, gauges and saws. In order to carry out monumental works from small studies,

Madonna of Capuchin

Luca Della Robbia, 1475
polychrome sandstone
National Museum, Bargello, Florence

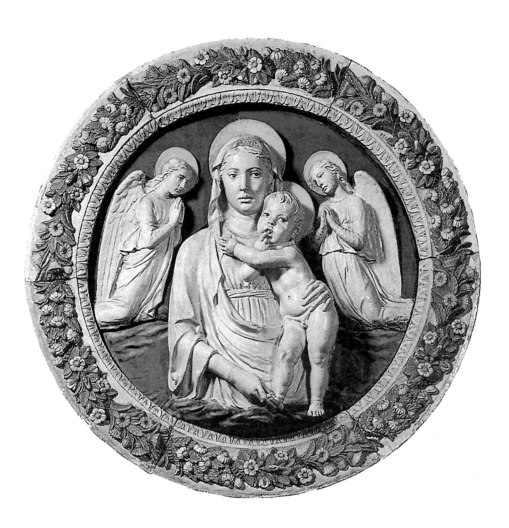

artists have developed various techniques of accurately reproducing the proportions of an original artwork. Bronze casting, another technique from the Antiquity, mastered by the Greeks and the Chinese and revived in the Renaissance, is still widely practiced.

Carthusian of Miraflores, Altar

1496-1499
Burgos

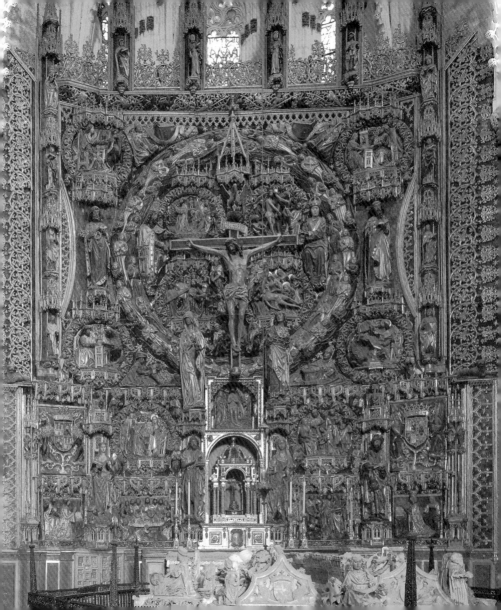

Metal can be cast solid, hammered, carved, or incised with forms. Sculptors use contemporary practices to emphasize the beauty of materials and of expression in metal sculpting. The 20th-century Surrealist sculpture uses the juxtaposition of contradicting objects while

Virgin at Stairs

Michelangelo, 1491-1492
relief in marble, 55.5 x 40 cm
Casa Buonarroti, Florence

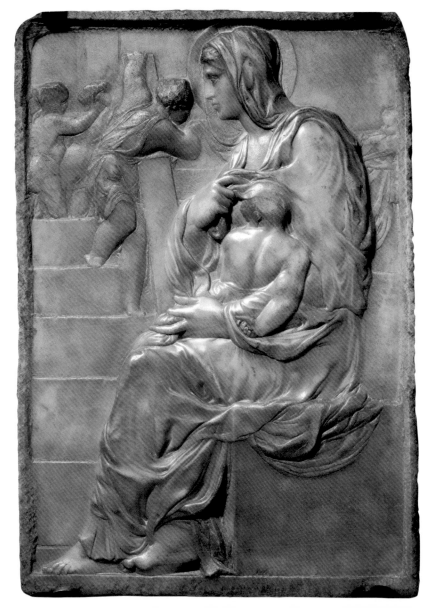

the artist Marcel Duchamp, with his rejection of any traditional artistic and cultural values placed himself as a Dadaist, and created "Ready-Mades" (*Fountain*, in 1917/1964, *Bicycle Wheel*, in 1913, *Bottle Rack*, in 1914/1964).

Blaubeuren Church Main Altar

Michel and Gregor Erhart, 1493-1494
central panel
Blaubeuren

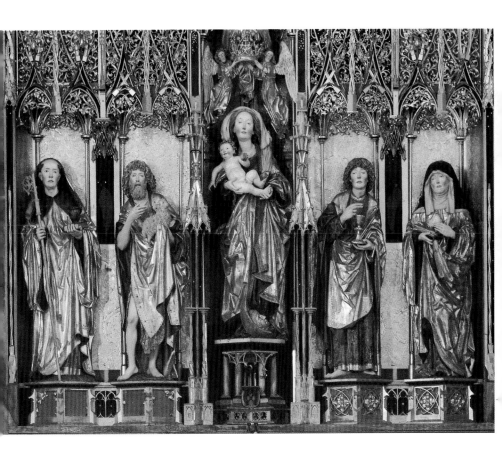

The Artists
Cesar Baldaccini (1921-1998)

Cesar Baldaccini was born in France and was at the forefront of the New Realism movement with his radical compressions (compacted automobiles, discarded metal, or rubbish), expansions (polyurethane foam sculptures), and fantastic representations of animals and insects.

The Dying Slave

———————————

Michelangelo, 1513-1516
marbre, 228 cm
The Louvre, Paris

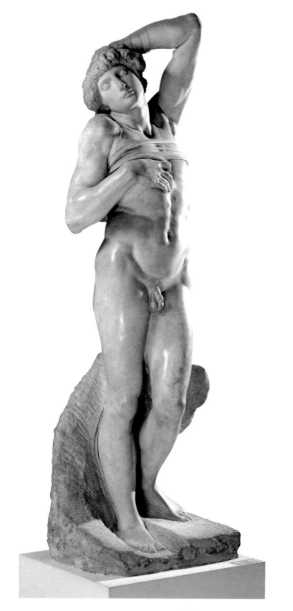

Richmond Barthé (1901-1989)

Born in 1901 in St Louis Bay, Mississippi, Richmond Barthé is today recognized as one of the leading artists of the 20th century. Despite a lack of formal training in art, the African-American Barthé was admitted to the Art Institute of Chigago.

Bacchus

———

Michelangelo, 1496-1497
marbre, 203 cm
Bargello National Museum, Florence

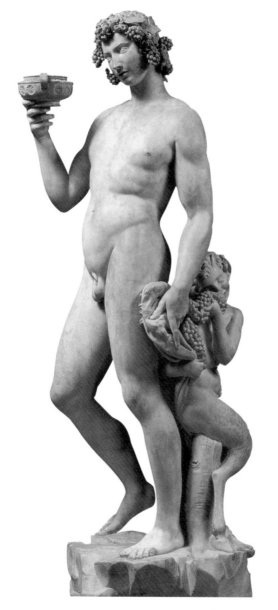

113

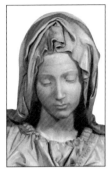

Initially a painter, Barthé started modeling in clay to allow him a better understanding of the third dimension as a way of broadening his painting. This experience proved to be the turning point of his career. Barthé gave up painting and began experimenting with sculpture.

Pietà

Michelangelo, 1498
marble, 174 x 195 cm
Basilica Saint Peter, Vatican

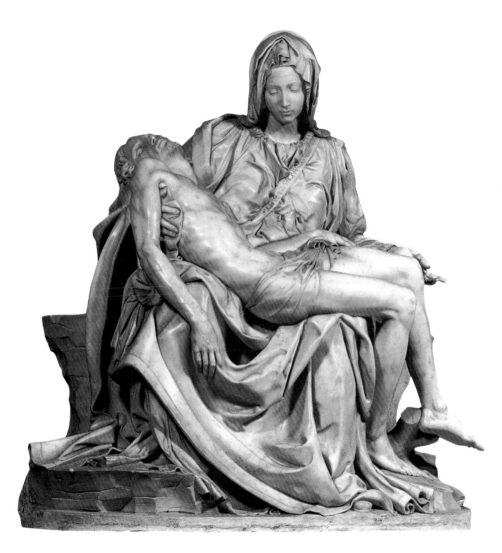

His first success came in 1928 from an exhibition at the Chicago Art League where he showed two busts that provoked great interest and admiration. In 1929, Barthé established himself in Harlem. His first solo exhibition took place in the Caz Delbo galleries and was an immense success and gained him recognition and celebrity.

David

Michelangelo, 1501-1504
marble, 410 cm
Galleria dell'Academia, Florence

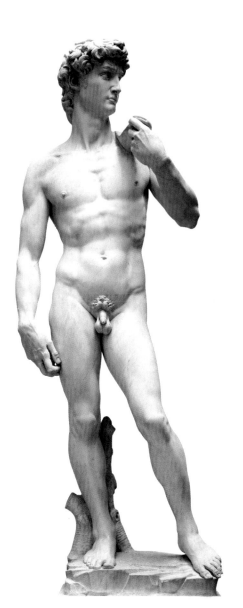

However, New York proved to be a dangerous and often violent place to live and Barthé decided to settle down in Jamaica. There he also felt uncomfortable and thus moved to Italy and then on to Spain finally settling in Switzerland for five years.

Madonna of Bruges

Michelangelo, 1506
marble, 128 cm
Church Notre Dame in Bruges

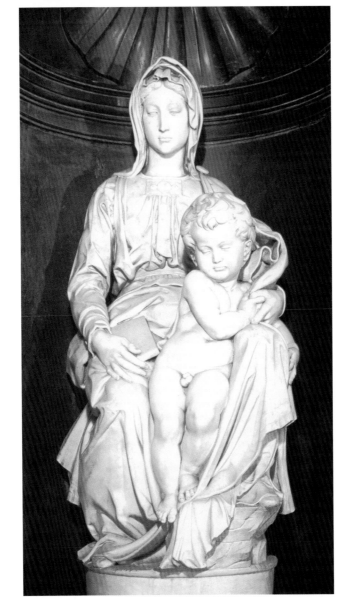

Barthé finished his rich life in Pasedena, California in 1989. His most famous works include the *Toussaint L'Ouverture Monument* in Port-au-Prince, Haiti, in front of the Palace, the *Walls of Jericho* in Harlem and the garden sculpture for the Edgar Kaufman house

The Rebellious Slave

Michelangelo, 1513-1516
marbre, 209 cm
The Louvre, Paris

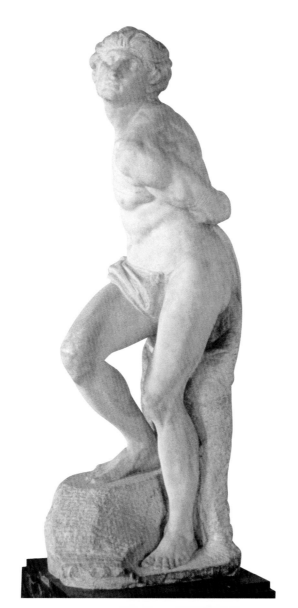

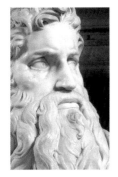

Falling Water, designed for Frank Lloyd Wright. Many of his works have been acquired by public collections and are included in museums such as the Metropolitan Museum in New York, the Whitney Museum of Art or the Art Institute of Chicago.

Moses

———

Michelangelo, 1513-1516
marble, 235 cm, tomb of Jules II
Church Saint-Peter-in-Chains, Rome

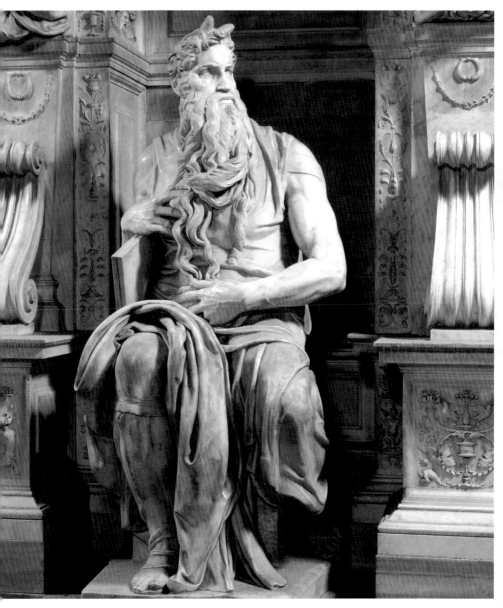

Constantin Brancusi (1876-1957)

Brancusi, who was Romanian but lived in Paris from 1904, worked in series, returning to a small number of motifs time and time again in order to develop and reinterpret his vision of a subject.

Saint Jerome

Pietro Torrigiani, 1523
sandstone, 160 cm
Monastery of Guadalupe (Caceres)

.

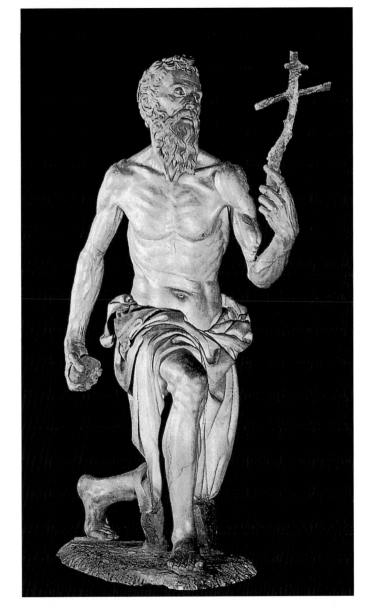

He was a highly skilled craftsman who evolved artistically very rapidly. His early influences included African as well as oriental art. Although Rodin was another early influence, Brancusi decided he wished to make much simpler work and began an evolutionary search for pure form.

Statue of Laurent de Medici

Michelangelo, 1524-1531
marble, 178.5 cm
Medici's Chapel, San Lorenzo, Florence

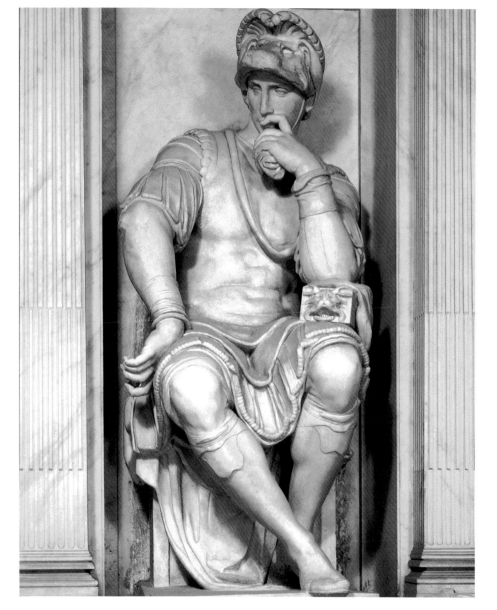

He reduced his work to a few basic elements. Paradoxically, this process also tends to highlight the complexity of thought that has gone into its making. Monumental, subtle and intimate, Brancusi's sculptures are rightly now considered to be the work of a modern master.

Victory
———
Michelangelo, 1530-1533
marble, 261 cm
Palazzo Vecchio, Florence

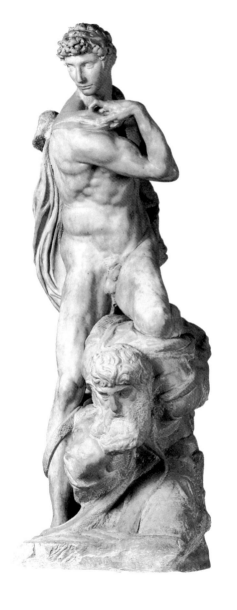

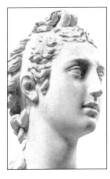

Antonio Canova (1757-1822)

The Italian sculptor was born in Possagno on 1 November 1757. He was the grandson of a very talented stonemason and passed his early life with him modelling in clay.

Apollo and Hyacinth

Benvenuto Cellini, 1545-1548
marble
National Museum, Bargello, Florence

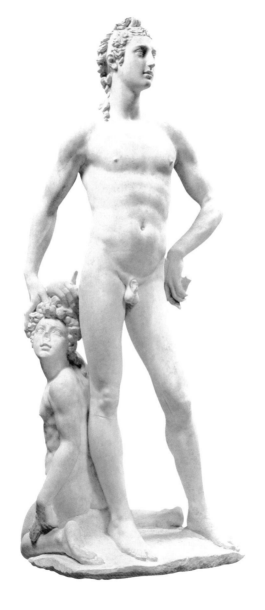

His talent was obvious and Senator Falieri, an influential man, noticed the young boy and placed him with the sculptor Torretto to learn his art. At the age of 16, he created his first work *Eurydice* followed by *Orpheus* and *Daedalus and Icarus*.

Pietà

———

Michelangelo, 1552
marble, 226 cm
Santa Maria del Fiore, Florence

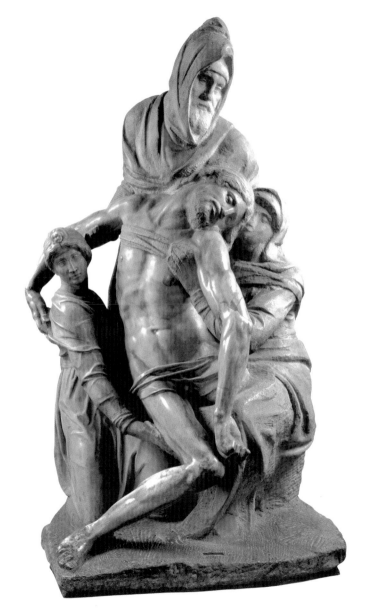

Canova went to Rome in 1780 where he was strongly influenced by Classical Antiquity. During this time, he modelled a masterpiece called *Theseus and the Minotaur* which is today in Vienna. He produced many other admirable works in Rome among which *Psyche and Cupid* in the Louvre and *Krengas and Damoxenus* in the Vatican Gallery.

Hermaphrodite Asleep

Bernini, 1620
marble
The Louvre, Paris

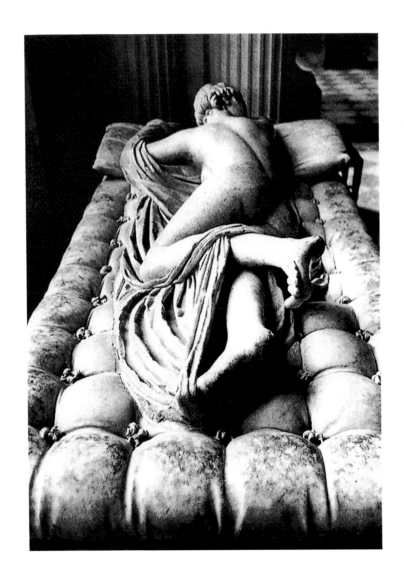

He was admired by Napoleon I from whom he received an important commission to execute a colossal statue of him. He became the imperial sculptor and portraitist of Napoleon's mother, Marie-Louise, Pauline Bonaparte and many other members of the court.

Bust of Louis XIV

Bernini, 1665
marble, 80 cm
Palace of Versailles

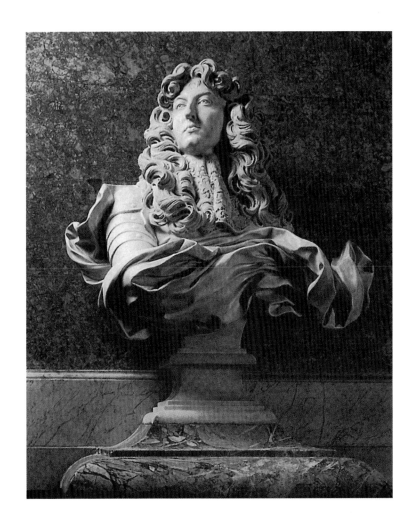

In Vienna, he was charged with the creation of a monument for Maria Christina, the Archduchess. His most famous portrait is probably the *Bust of Pius VII* created in 1907. Promoted by the Pope, given the title of Marquis of Ischia, Canova made a huge statue named *Religion*.

Apollo served by Nymphs

François Girardon and Thomas Regnaudin, 1666
marbre, still-life
Palace of Versailles garden

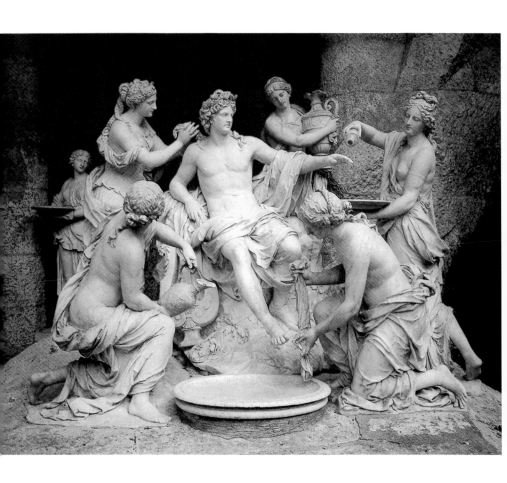

Many other commissions followed, among which feature famous masterpieces such as *Infant St. John*, *The Recumbent Magdalena*, a statue of Washington and his Pietà. Other important commissions include the tombs of two popes, Clement XIII and Clement XIV.

Milon de Crotone

Pierre Puget, 1680
marble, 270 cm
The Louvre, Paris

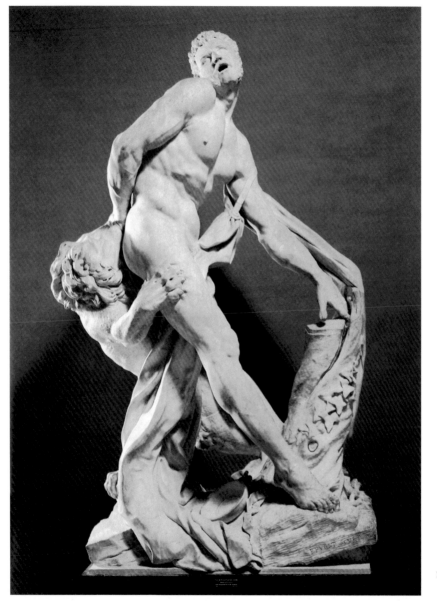

He died on 13 October 1822 in Venice and was buried in Possagno where he had been born 65 years earlier. It was Canova who defined classical, elegant sculpture and was of primary importance in the development of the neoclassical style.

Marie-Adélaïde de Savoie
Duchess of Bourgogne

Antoine Coysevox, 1710
marble, 195 cm
The Louvre, Paris

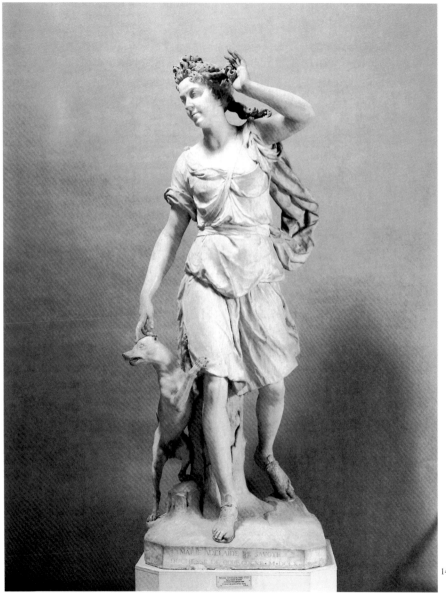

143

Jean-Baptiste Carpeaux (1827-1875)

Jean-Baptiste Carpeaux was born on 11 May, 1827, in Valenciennes. His father was a stonemason and the family lived in great poverty. At the age of 15 he moved to Paris and two years later he was admitted to the Ecole des Beaux-Arts.

Power figure (nkisi nkonde)
from Zaire

───────────

1802
Wood, nails, pins, blades and other materials, 111.7 cm
The Field Museum, Chicago

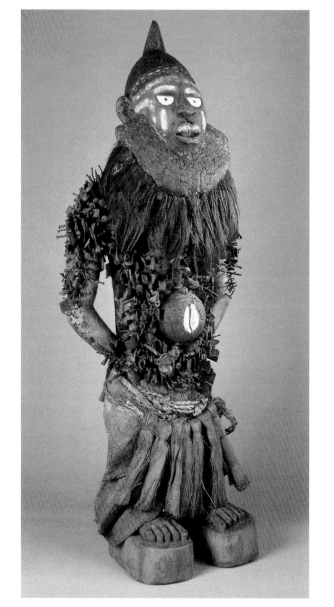

145

He executed the much admired statue of *Hector and Astyanax* for which he was awarded the Grand Prix de Rome in 1854. Disagreeing with the French Academy and fascinated by the works of Michelangelo and Donatello he decided to move to Rome in 1856.

Ancestor Screen (duen fobara)
from Nigeria

1802
The Minneapolis Institute of Arts

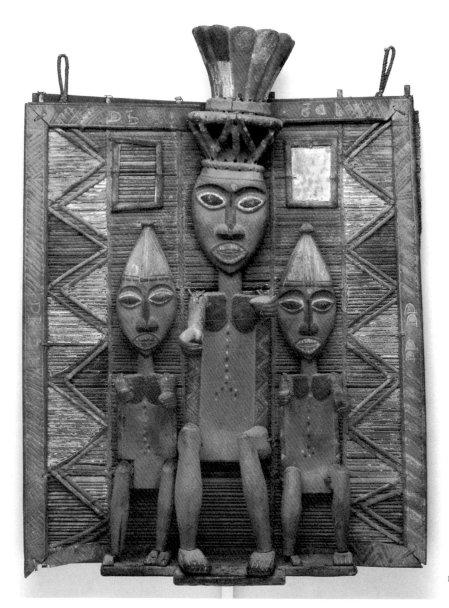

147

In Rome, he created, amongst others, his masterpiece, a dramatic group based on Dante's inferno, *Ugolino and His Sons*. Although it only gained him a second-class medal at the Salon, it was admired by Napoleon and the court assuring him permanent success as well as notoriety.

Pauline Borghèse in Vénus victrix

Antonio Canova, 1804-1808
marble
Villa Borghese, Rome

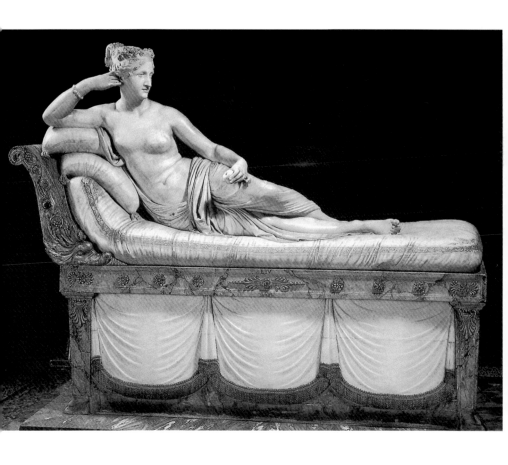

The Imperial Prince commissioned a statue from him. Among other famous works, he decorated the Pavillon de Flore and designed the frontispiece of the town hall of Valenciennes. Whilst in London in 1871, he sculpted a bust of Gonnod.

Mars and Venus
——————————
Antonio Canova, 1816-1822
marble, 210 cm
Gipsoteca Canoviana, Possagno

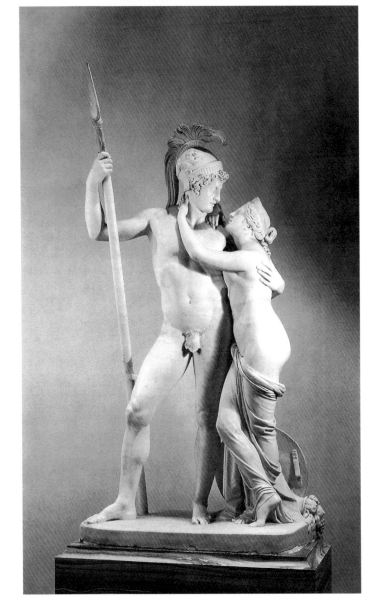

151

Another of his later masterpieces was the Parisian fountain: The Four Quarters of the World, featuring a globe which is held by four female sculptures representing the four continents. He received many honours during his life. His best sculptures are noble in conception, his style was naturalistic and full of emotion. He died in 1875 near Paris.

Reliquary Guardian (nlo byeri)
from Gabon

———

1805
Wood, 43 cm
Musée Dapper, Paris

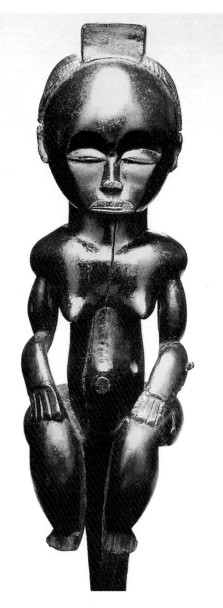

153

Benvenuto Cellini (1500-1571)

Benvenuto Cellini was born on 1 November 1500 in Florence in Italy. He was educated by a goldsmith and at the age of 15 was taken on as apprentice in his workshop.

Xenobia in Chains

Harriet Hosmer, 1859
marble
Wardsworth Atheneum, Hartford, Connecticut

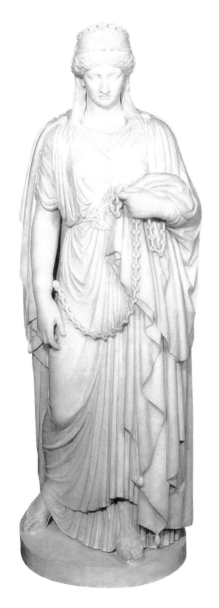

Due to his extremely difficult character which was regularly a cause of conflict, he was exiled to Sienna. He later fled and returned to Rome where he became Michelangelo's student for a short time. Michelangelo would go on to inspire him for the rest of his life.

The Dance

Jean-Baptiste Carpeaux, 1865-1869
stone, 420 cm
Musée d'Orsay, Paris

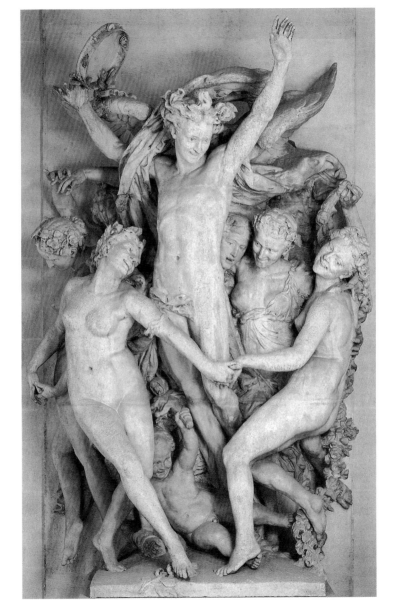

In 1529, back in Rome, Cellini opened a goldsmith workshop of his own where he created some of the most beautiful works of the Renaissance such as jewelry, ornaments, crafted vases and many other exquisite objects.

The Thinker

Rodin, 1880-1881
bronze, 68.5 x 89.5 x 51 cm
musée Rodin, Paris

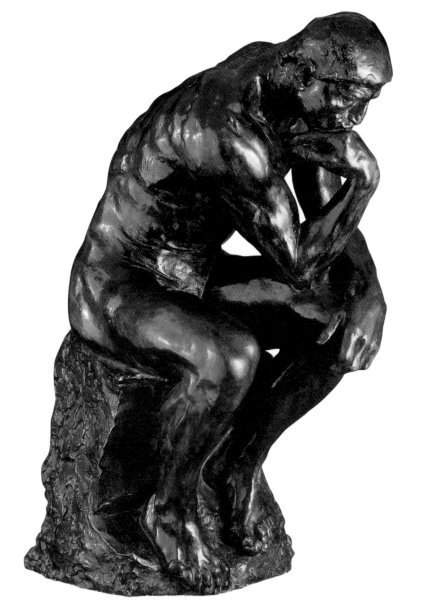

Cellini enjoyed the patronage of many famous people among whom feature the Popes Clement VII and Paul III, Francis I of France, who commissioned the Nymph of Fontainebleau and the *Gold Salt and Pepper Holder* respectively in the Louvre,

The Helmet-Maker's Wife

Rodin, ca. 1887
bronze, 94.5 x 30.5 x 19.5 cm
musée Rodin, Paris

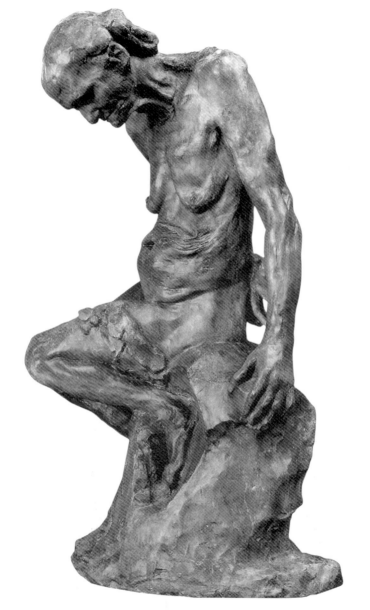

Paris and in the Kunsthistorisches Museum in Vienna, particularly adapted to the refinement of the Mannerist style. In 1545, this artistic genius was once again obliged to flee. The trouble originated in quarrels with the king's mistress.

Torso of Adèle

Rodin, 1882
plaster, 15 x 45 x 23 cm
musée Rodin, Paris

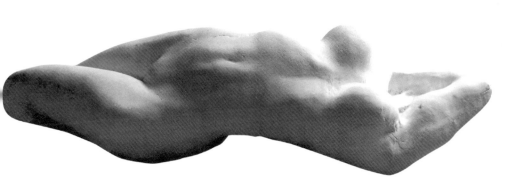

He returned to Florence under the protection of Cosimo I de Medici of whom he executed an admired bust portrait in bronze as well as an enormous bronze statue, *Perseus and Medusa*. Some of the best metal works of the Renaissance, noble in conception and in form,

Victor Hugo

─────────

Rodin, 1883
bronze
musée Rodin, Paris

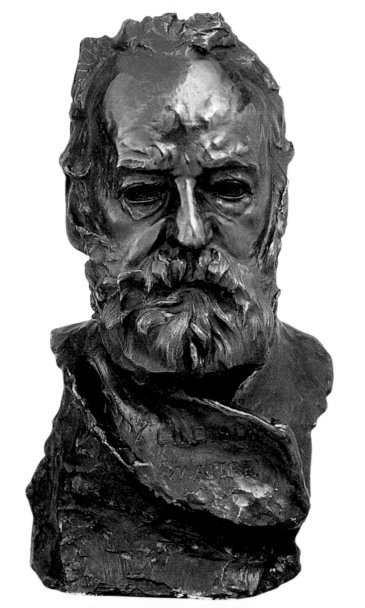

were executed by Cellini. He achieved as much fame from his autobiography as he did from his works of art. It was an instant hit with its lively account of his tumultuous life and its vivid picture of renaissance Italy.

The Age of Bronze

Rodin, 1877
bronze, 104 x 35 x 28 cm
musée Rodin, Paris

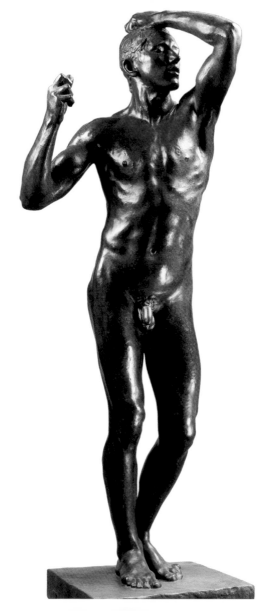

Charles-Antoine Coysevox
(1640-1720)

Charles-Antoine Coysevox was born on 29 September in Lyon, France, to a family of Spanish origin. His artistic talent was developed very early and by the time he was seventeen,

The Thought

———————

Rodin, 1886
marble
musée Rodin, Paris

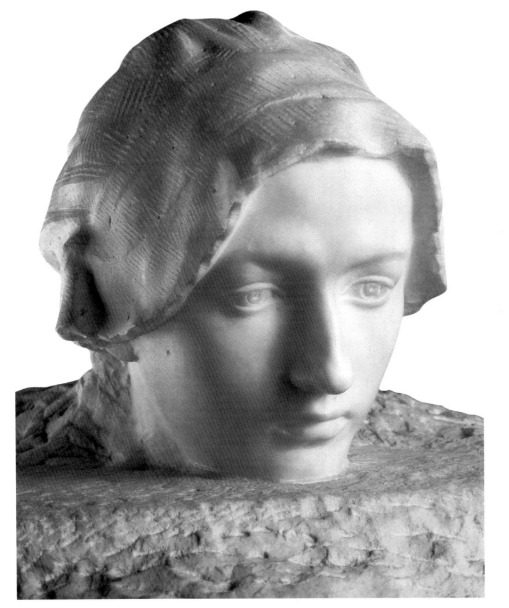

he modeled his first statue, an admirable
Madonna. In 1671, by special request of
Louis XIV, the young sculptor executed
various monuments in Versailles and in
Marly. He also made decorative sculptures

The prodigal Son

———————————

Rodin, ca. 1886
plaster
musée Rodin, Paris

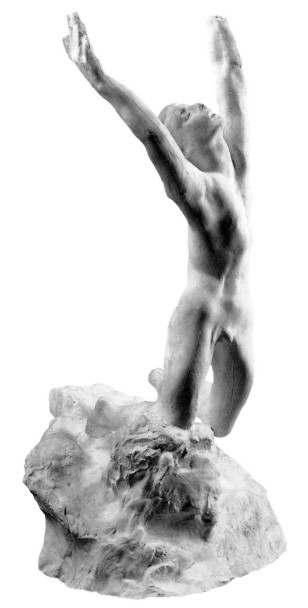

171

for the royal gardens and many interior designs. In 1676, in acknowledgement of his art, he waselected a member of the Academy, a great honour for an artist. He was commissioned to make bronze statues of Louis XIV and Charlemagne,

The Kiss

Rodin, 1888-1889
marbre, 181.5 x 112 x 117 cm
musée Rodin, Paris

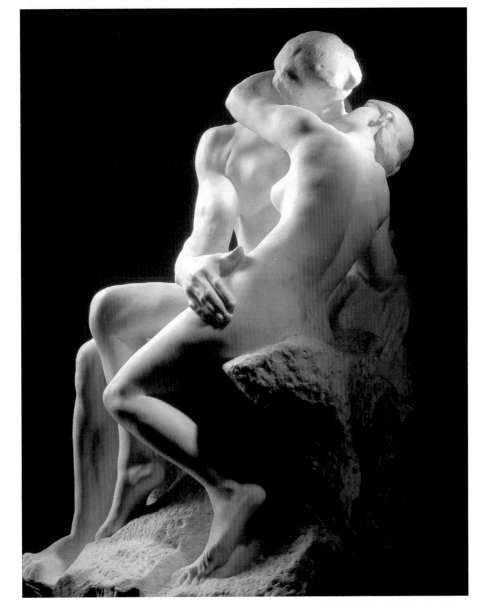

which can be admired at St-Louis-des-Invalides, a church in Paris. His most notable achievement is probably *La Renommée* which embellishes the entrance of the Tuileries, representing a winged horse, bearing Mercury and Fame.

The Citizens of Calais

Rodin, 1889
bronze, 217 x 255 x 177 cm
musée Rodin, Paris

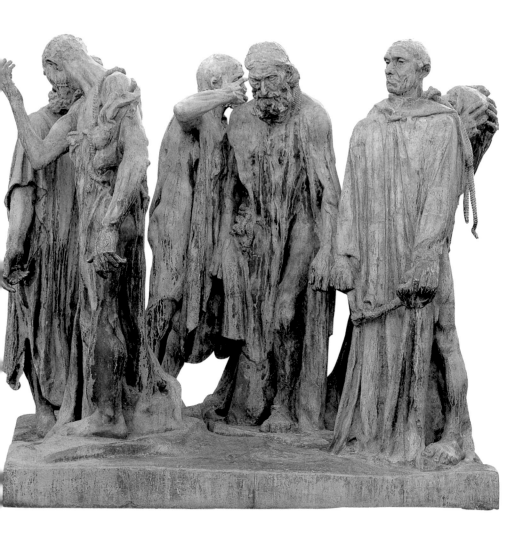

The exquisite lines of some of the monuments for churches in Paris come from his hands and are among the most notable artistic achievements of the city, where he died on 10 October 1720 at the age of 80.

Danaid

Rodin, ca. 1889
marbre, 32.5 x 71.8 x 57 cm
musée Rodin, Paris

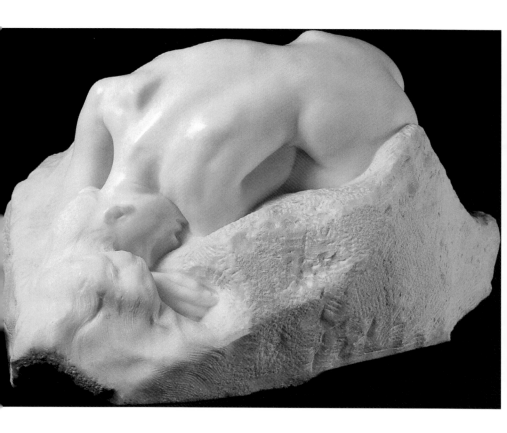

Donatello (1383-1466)

Named 'Donato' at birth, Donatello was born in 1383 in Florence, Italy. He started sculpting in his early youth, inspired by Classical and medieval characters. The first work of his is the *Annunciation*, a stone carving for the Church of St Croce.

The Gates of Hell

———————

Rodin, 1880-1890
bronze
musée Rodin, Paris

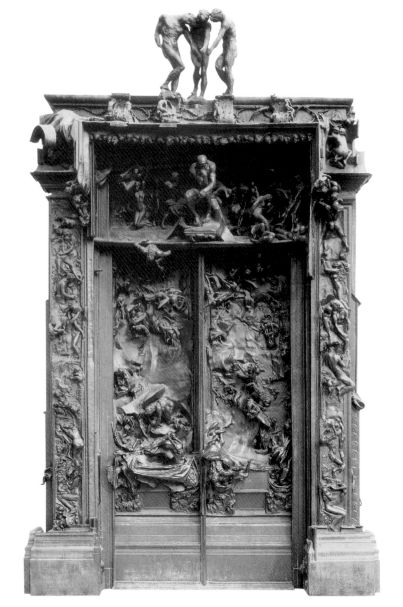

179

The young artist then created the admirable Daniel, St John the Evangelist and other statues for the façade of St Maria del Fiore, graceful compositions exquisitely executed. Some of his best sculptures were given to the Martelli family whom he profoundly loved, among which feature *David* and *St John.*

The Farewell

Rodin, 1892
plaster
musée Rodin, Paris

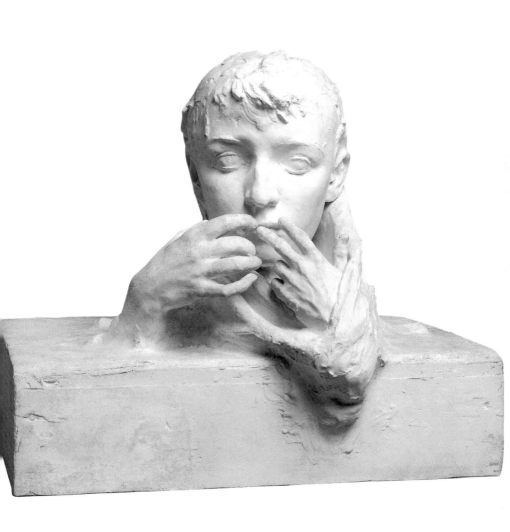

Donatello's most notable achievements are found in Florence, the city that he deeply loved. He elevated the status of his sculpture to such an admirable level that it continues moving us today.

Mask of Téha'amana

Paul Gauguin, 1892
polychrome wood, 25 x 20 cm
Musée d'Orsay, Paris

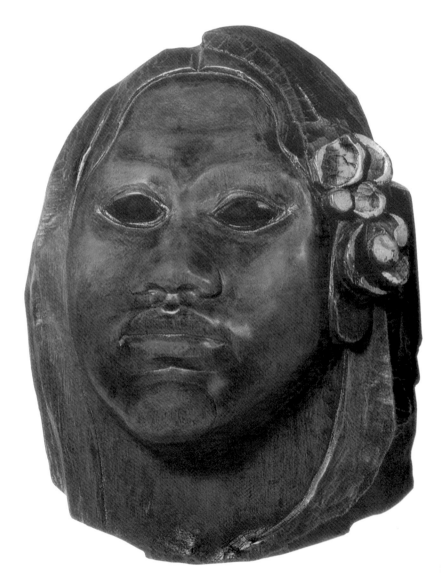

183

Donatello was buried in 1466 in Florence. He is said to be the greatest European sculptor of the 15th century, influencing painters and sculptors alike. Moreover, Donatello was one of the founders of the Renaissance style.

Idol with Shell

Paul Gauguin, 1892
wooden statuette, mother-of-pearl
bone teeth, 24 x 14 cm
Musée d'Orsay, Paris

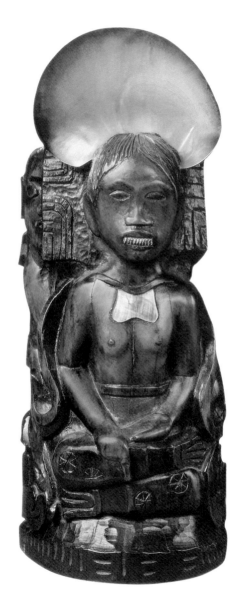

Jean Dubuffet (1901-1985)

Jean Dubuffet was born in Paris and studied painting there. However, in 1929 he began to make a living as a wine merchant. In the early 1940s he returned to art full-time and became a leading artist in Paris as well as a proponent of 'brut *art*'.

Surprised Woman

Edgar Degas, 1896-1911
bronze, 41 x 28 x 19.2 cm
The Norton Simon Museum, Pasadena

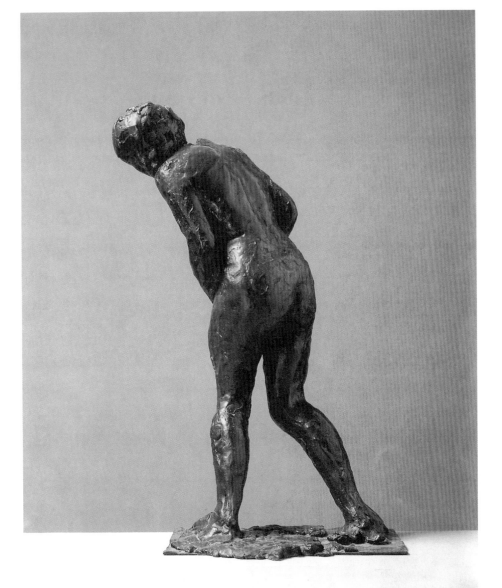

He executed crude images which he formed by incising rough impasto surfaces made of materials such as sand, plaster, tar, gravel, and ashes bound with varnish and glue, and sculptural works made of junk material.

The Walking Man

Rodin, 1900-1907
bronze, 213.5 x 71.7 x 156.5 cm
musée Rodin, Paris

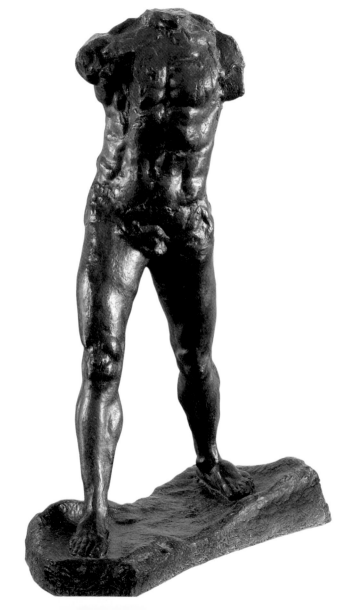

Henri Matisse (1869-1954)

Henri Matisse was born in the north of France in 1869. It was in 1890 that he was first attracted to painting. His hobby overtook him and he decided to take up painting as a career.

Magdalene I

Henri Matisse, 1900
Bronze, 59.1 x 22.2 x 18.1 cm

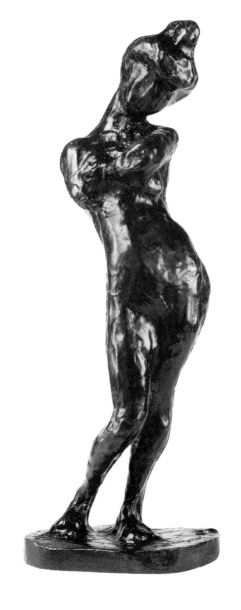

In 1896, he made a successful début at the Salon de la Société Nationale des Beaux-Arts. He later entered the Académie Carrière where he met Derain and Puy and attended evening classes in sculpture. However, it was only around 1912 that sculpture started to occupy a significant place in Matisse's artistic career.

Amulet

———

1911
bone, glass beads, hide and intestinal
membranes of sea creatures, 12 cm

Matisse let his sculptural preoccupations invade his painting. The distortions and the simplifications of the nude anatomy in his paintings reflect those that feature in certain bronze sculptures from the same time.

Oviri

Paul Gauguin
stoneware, 75 x 19 x 27 cm
Musée d'Orsay, Paris

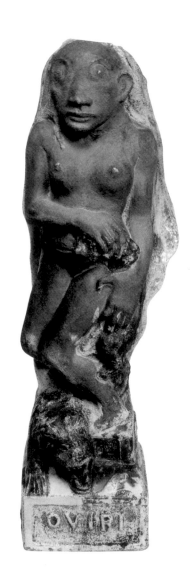

Henry Moore (1898-1986)

The son of a coalminer, he was able to study at the Royal College of Art through a rehabilitation grant after being wounded in World War I. His early works were strongly influenced by the Mayan sculpture he saw in a Parisian museum. From around 1931 onwards,

Spirit spouse (blolo bla)
from Côte d'Ivoire

1905
wood, 43.5 cm
University Museum of Pennsylvania, Philadelphia

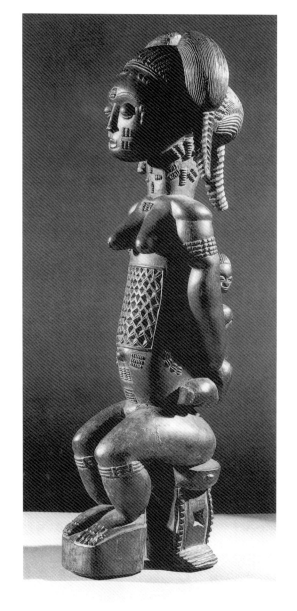

he experimented with abstract art, combining abstract shapes with the human figures and at times leaving the human figure behind altogether. Much of his work is monumental, and he is particularly well known for a series of reclining nudes. His work is characterized by organic forms, abstraction and his use of bronze and stone.

The Cathedral

Rodin, 1908
stone
musée Rodin, Paris

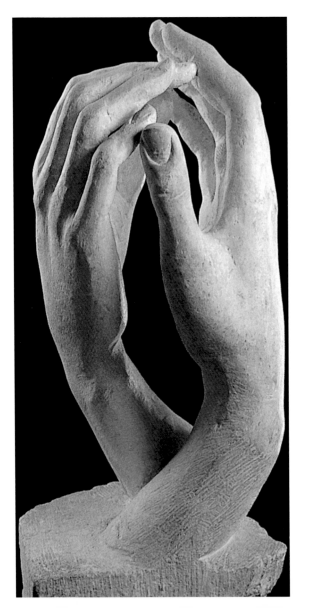

Bruce Naumann (1941)

Bruce Naumann was born in Fort Wayne, Indiana on 6 December 1941. During his youth, he learnt how to play the classical guitar and piano. Later, at Wisconsin University, he went on to study music on an informal basis together with mathematics,

Dancing Woman

Ernst Ludwig Kirchner, 1911
wood painted in yellow and black, 87 cm
Stedelijk Museum, Amsterdam

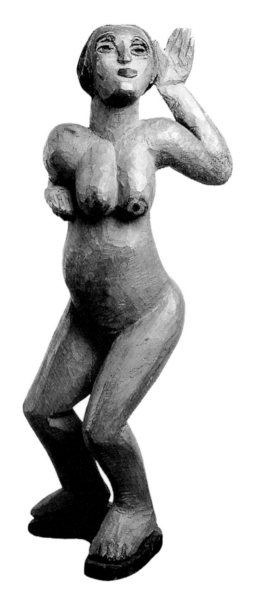

201

physics and art as well as philosophy. Naumann was initially a painter but gave up this medium in 1964 to consecrate his time and talent to experimenting with sculpture and performing arts as well as film holograms, photographs, films and research.

Head

Amedeo Modigliani, 1911-1913
sandstone, 63.5 x 15.1 x 21 cm
Solomon R. Guggenheim Museum, New York

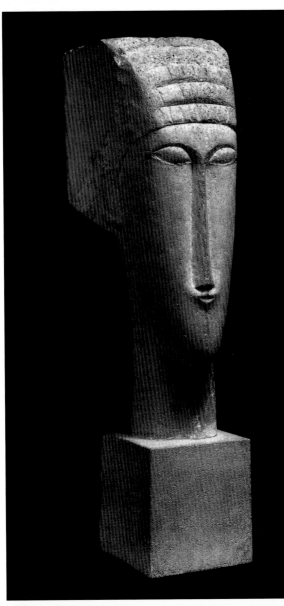

Until 1970, he divided his life between teaching to earn a living and his conceptual art work. His first solo exhibition took place in 1966 in Los Angeles at the Nicholas Wilder Gallery, followed two years later in New York with a solo exhibition at the Leo Castelli Gallery.

Carved Miniature : Silhouette of a Nude Woman

1911
walrus ivory, 5.3 cm
Kamchatka

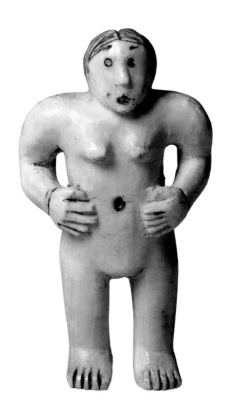

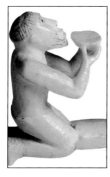

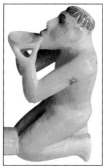

These two shows were the beginning of a long series of solo exhibitions in America and in Europe. He received much admiration from critics and the public and participated in Documenta 4 in Kassel, Germany.

Carved Miniature: Tea Time and Trapeze

1911
walrus ivory, 6 x 6.7 x 4.5 x 4 cm
Kamchatka

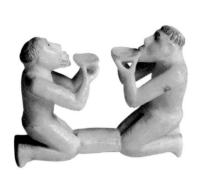

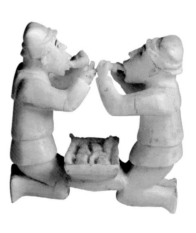

Naumann experienced success after success as his exhibitions traveled throughout Europe and the United States. In 1979 he settled down in New Mexico. His work is focused mainly on the medium of neon, video installations and sculpture.

Standing Figure

Amedeo Modigliani, ca. 1912-1913
Limestone, 162.8 x 32.2 x 26.6 cm
Australian National Gallery, Canberra

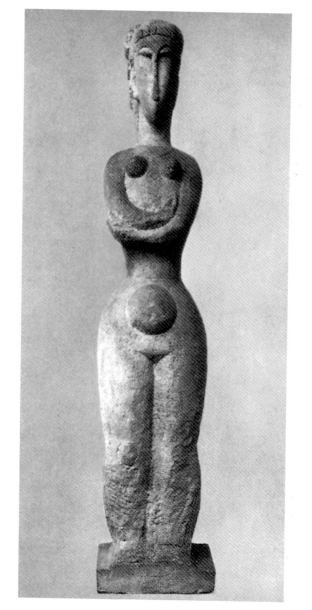

His themes and imagery revolve around animal parts, namely horse and human body parts. He now lives and works in Galisteo, New Mexico and is recognised as one of the foremost sculptors and video artists of his generation.

Caryatid
———

Amedeo Modigliani, 1914
Limestone, 92.1 x 41.6 x 42.9 cm
The Museum of Modern Art, New York

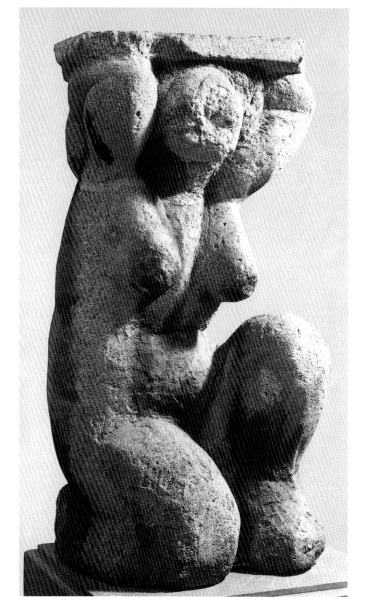

211

Pierre Puget (1620-1694)

Pierre Puget was born in 1620 in Marseilles, France. He was an artistic genius but a difficult person and was kept away from the court. His work was considered too personal and too impassioned to please the court, then under the artistic influence of Le Brun.

The Absinth Glass

Pablo Picasso, 1914
bronze painted upon a model
21.5 x 16.5 x 8.5 cm
The Museum of Modern Art, New York

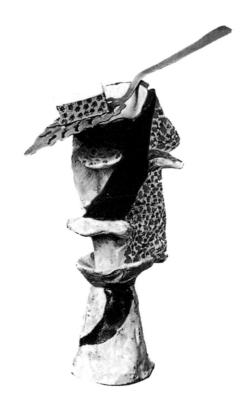

It was greeted with indignant protests, not because of any fault but that of exceeding the prescribed limitations. In 1640, he left Marseilles for Rome where he stayed until 1643.

Column

Naum Gabo, 1923
glass, plastic, wood and metal, 105.5 cm
Tate Gallery, London

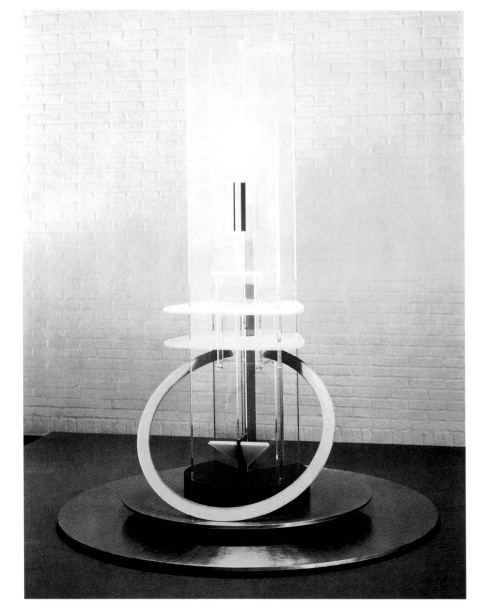

Puget worked in Rome together with Pietro da Cortona to whom he owes his Baroque Style. Back in Marseilles, full of energy after having traveled around Italy, he produced some of his major works among which are two remarkable Atlas figures that embellish the entrance of the Forum Hall.

Bird in Space
———
Constantin Brancusi, 1925
marble, 134 cm
Kunsthalle, Zurich

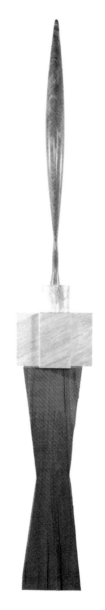

His next notable work is his famous *Milon of Crotona* which can be admired in the Louvre in Paris. Puget died in Marseilles in 1694, embittered and discouraged by the lack of recognition from the King and his court.

Ritual Mask

1930-1935
wood, tendons, 30.7 x 16 cm

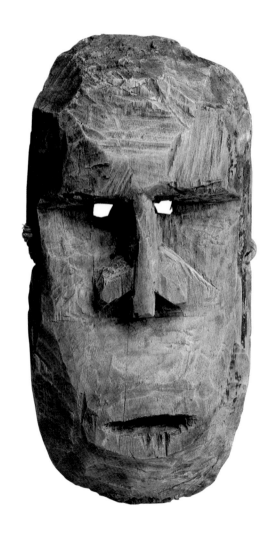

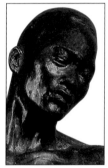

Robert Rauschenberg (1925)

Robert Rauschenburg was born Milton Rauschenberg on 22 October, 1925, in Port Arthur, Texas. In 1947 he enrolled at the Kansas City Art Institute and traveled to Paris to study at the Académie Julian the following year.

Feral Benga

Richmond Barthé, 1937
bronze, 50.8 cm
Museum of Fine Arts, Houston

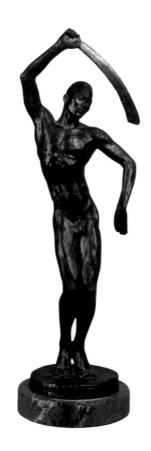

While taking classes at the Art Students League in New York from 1949 to 1951, Rauschenberg was offered his first solo exhibition at the Betty Parsons Gallery. He became one of the major artists of his generation and is credited along with Jasper Johns with breaking the stronghold of Abstract Expressionism.

Breakfast in Fur

Meret Oppenheim, 1936
bowl, saucer and spoon covered by fur
Museum of Modern Art, New York

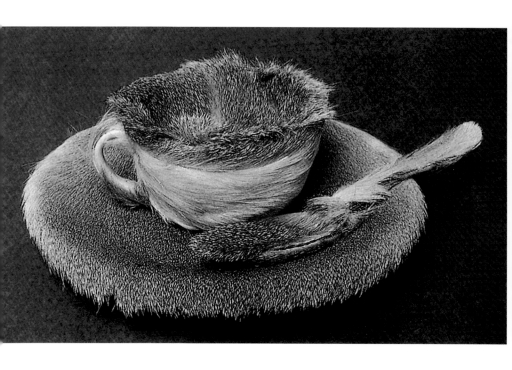

He is considered one of the pioneers of Pop Art. It was around 1954 that Rauschenberg began breaking down the rigidly held barriers between the mediums of painting and sculpture by combining both mediums into one. As was often the case with the Pop artists, Rauschenberg's work repeatedly pulls the realms of art and the everyday into close proximity.

Three Standing Figures

Henry Moore, 1945
plaster with surface colour, 21.6 cm

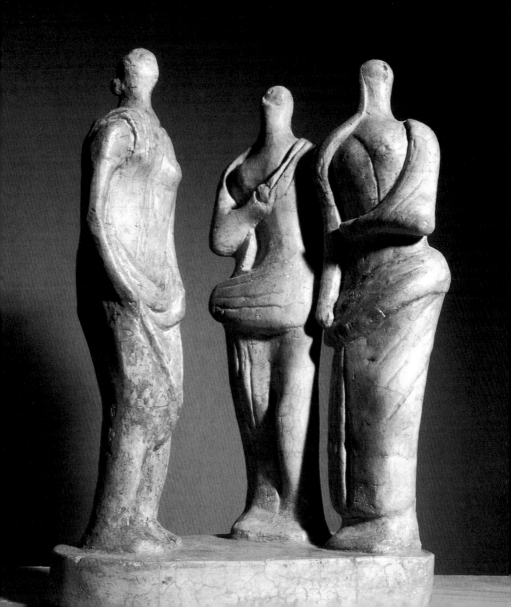

Luca della Robbia (1399/1400-1482)

The first works by Luca (di Simone di Marco) Della Robbia were sculpted marble reliefs, most notably those for the Cantonia (singing-gallery) of Florence Cathedral (1432-1437).

Goat

———

Pablo Picasso, 1950
plaster, wood, metal, 120.5 x 72 x 144 cm
Musée Picasso, Paris

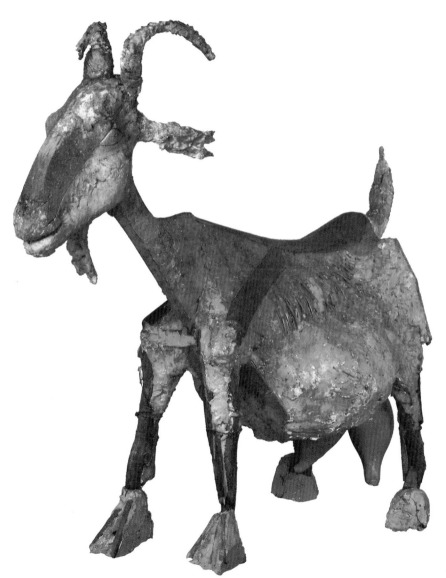

He is remembered mainly for his development of glazed terra-cotta as a medium for sculpture; his major terra-cotta works include roundels of the Apostles (c.1444) in Filippo Brunelleschi's Pazzi Chapel in Santa Croce.

Little Girl with a Rope

Pablo Picasso, 1950
plaster, ceramic, shoes, wood and metal
152 x 65 x 66 cm
Musée Picasso, Paris

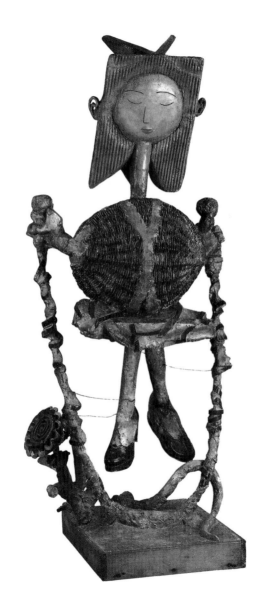

Auguste Rodin (1840-1917)

Auguste Rodin was born on 12 November, 1840, in Paris. In 1854, he took his first art classes in a drawing school at the Petite Ecole but repeatedly failed to enter the Ecole des Beaux-Arts.

The Wood

Alberto Giacometti, 1950
bronze, 57 x 46 x 58 cm

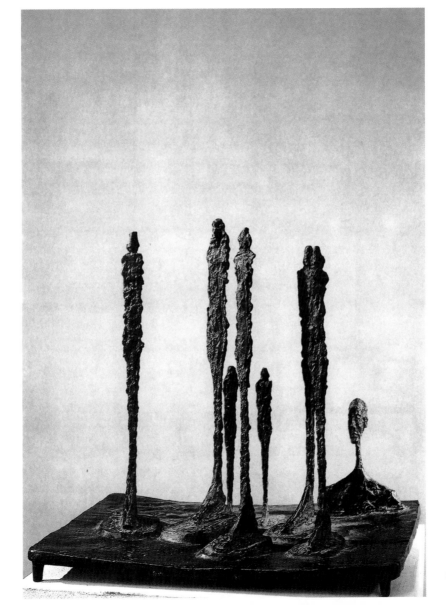

Hence, Rodin was obliged to earn a living decorating stone work. The death of his beloved sister Marie was a turning point in his life. Grief stricken by her death, Rodin went to the Très-Saint-Sacrament, a Catholic Order.

Monkey with his Child

Pablo Picasso, 1951
ceramic, metal and plaster
56 x 34 x 71 cm
Musée Picasso, Paris

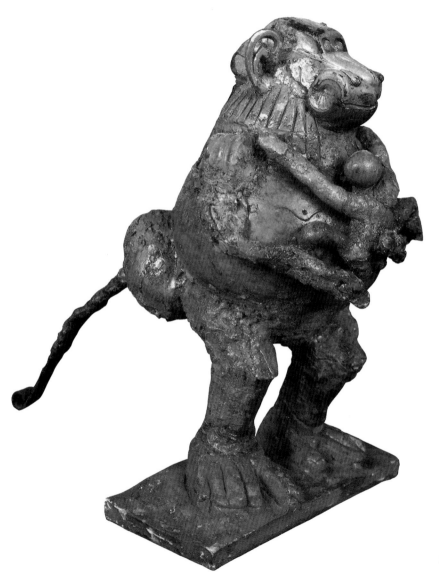

He attracted the attention of his superiors with his unusual ability and they convinced him to continue his art. At the age of 24, Rodin met Rose Bennet, his model, his mistress and much later his wife. During that time Rodin submitted his first work at the Salon, *The Man with a Broken Nose.*

Monogram

Robert Rauschenberg, 1955
mixed technique, 122 x 183 x 183 cm
Modern Museum, Stockholm

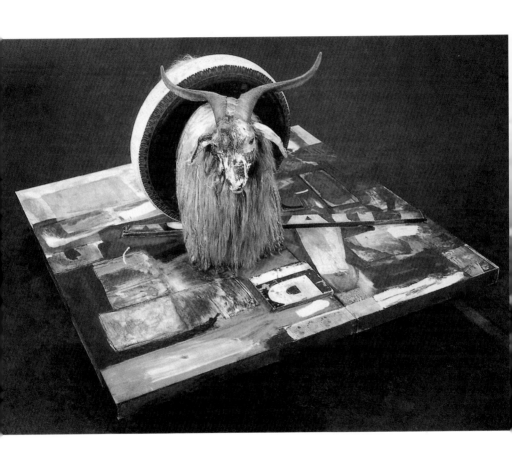

He traveled to Rome and was fascinated by Michelangelo to whom he owes his sense for vehement and passionate action. The influence he drew from his stay in Italy is evident in his sculpture *The Age of Bronze*, executed after his return.

Compression

César, 1962
153 x 73 x 65 cm

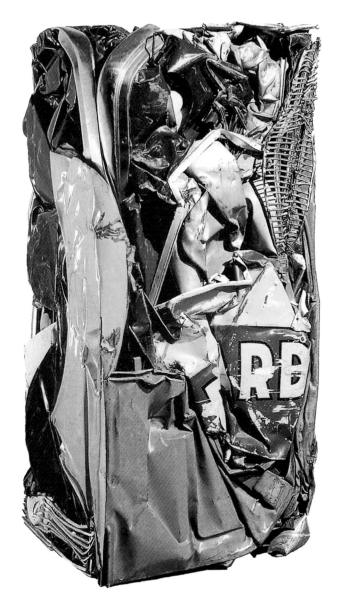

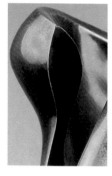

Although much criticized when unveiled in Paris and even greeted with indignant protest, it made him known and helped him build his reputation. His works include *The Thinker* (1888) and *The Kiss* (1888–9) as well as portraits of Victor Hugo and Honoré de Balzac, all of which caused controversy for their unconventionality.

Divided Head

1963
bronze, 35 cm
Fiorini, London

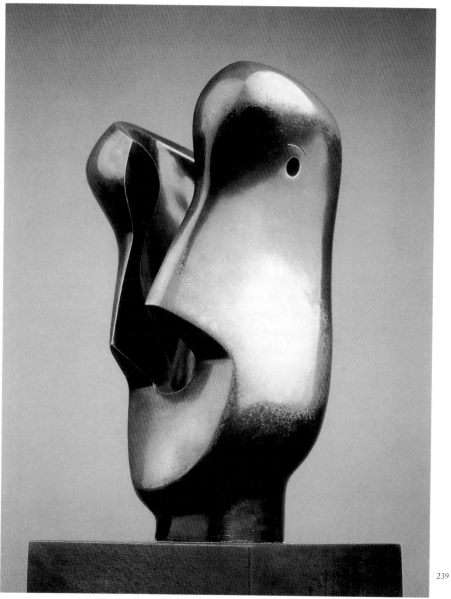

In 1880, he received an important commission to execute a bronze door for the Museum of Decorative Arts which, although unfinished, is a fine piece of work. It is said that Rodin revitalized sculpture as an art of personal expression.

Pink Delivery

Niki de Saint-Phalle, 1964
mixed techniques, 219 x 152 x 14 cm

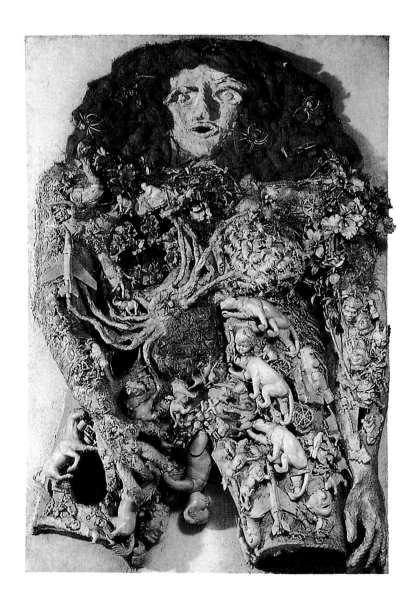

Niki de Saint-Phalle (1930-2002)

Daughter of a rich French banker and an American heiress, Niki de Saint-Phalle spent her childhood and adolescence in both America and in France. For her, painting and art would prove to be a kind of therapy.

From hand to mouth

Bruce Nauman, 1967
wax on canvas, 76.2 x 25.5 x 10.2 cm

From 1956 to 1961, she constructed pieces from wood and cardboard. Some of her most extraordinary work includes her *Tarot Garden* sculptures in Tuscany. Niki de Saint-Phalle is also known for her oversized figures which embrace contradictory qualities such as good and evil.

Portative Landscape

Jean Dubuffet, 1968
polyester, 80 x 130 x 75 cm

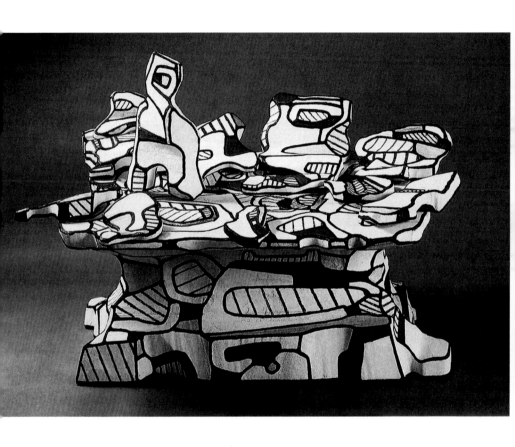

Her exaggerated "earth mother" sculptures, the 'Nanas', playfully explore the ancient tradition of feminine deities while celebrating modern feminism's efforts to reconsider and revalue the woman's body.

Figure lying in three parts: draped

Henry Moore, 1975
bronze, 446 cm
Museum of Fine Arts, Teheran

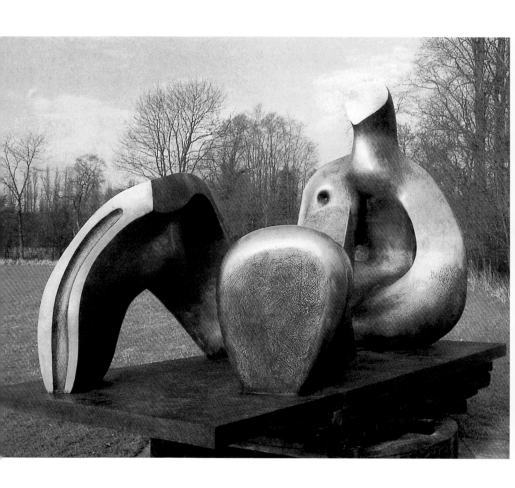

247

Index

A

Ajax and Patroklos 69

Akhenaten and his Family 19

Amulet 193

Ancestor Screen (duen fobara) from Nigeria 147

Antinous 73

Aphrodite of Cnidos 55

Apollo and Hyacinth 131

Apollo in the Temple of Portanaccio of Véies 33

Apollo served by Nymphs 139

Apoxyomenos 57

Ara Pacis Augustae: The Procession 71

Aryballos. Vase in the Form of a Kneeling Athlete 27

B

Bacchus 113

Barberini Faun 63

Bird in Space	217
Blaubeuren Church Altar	109
Bust of Louis XIV	137
Breakfast in Fur	223

C

Carthusian of Miraflores, Altar	105
Carved Miniature : Silhouette of a Nude Woman	205
Carved Miniature : Tea Time and Trapeze	207
Caryatid	211
Column	215
Compression	237

D

Danaid	177
Dancing Woman	201
David	93
David	117
Diana the Hunter	81
Divided Head	239
Doryphorus (Spear-Carrier)	47

F

Feral Benga 221
Figure lying in three parts: draped 247
From hand to mouth 243

G

Goat 227

H

Harmodius and Aristogiton The Tyrannicides 37
Head 203
Head attributed to Brutus the Old 61
Hera of Samos 29
Hermaphrodit 135
Hermes with Sandal 59

I

Ibex Porter 21
Idol 11
Idol with Shell 185

J

Jesus and Saint John the Beloved 87
Jesus and Saint John the Beloved 89

K

Kouros from Anavyssos 31

L

Little Girl with a Rope 229

M

Magdalene I 191

Madonna of Bruges 119

Madonna of Capuchin 103

Marie-Adélaïde de Savoie duchess of Bourgogne 143

Mars and Venus 151

Mary Magdalene 99

Mask of Téha'amana 183

Metope from the Selinonte Temple, The Acteon's Punishment 45

Milon de Crotone 141

Moses 123

Monkey with his Child 233

Monogram 235

O

Oviri 195

P

Pan teaching the Flute to Olympos 53

Pauline Borghèse in Vénus victrix 149

Personification of the Nile 75

Pietà 115

Pietà 133

Pink Delivery 241

Portative Landscape 245

Portrait of a Woman 79

Power figure (nkisi nkonde) from Zaire 145

Prophet Isiah 85

R

Reliquary Guardian (nlo byeri) from Gabon 153

Ritual Mask 219

S

Saint Jerome 125

Sesostris III 17

Sitting Writer 13

Spinning Woman 25

Spirit spouse (blolo bla) from Côte d'Ivoire 197

Standing Figure 209

Statue from Riace 51

Statue of Laurent de Medici 127

Surprised Woman 187

T

Tabernacle 95

The Absinth Glass 213

The Age of Bronze 167

The Belvedere Apollo 77

The Big Cameo of France 67

The Brassempouy Lady, Grotte du Pape 9

The Cathedral 199

The Citizens of Calais 175

The Dance 157

The Deposition 83

The Dying Slave 111

The Farewell 181

The Gates of Hell 179

The Helmet-Maker's Wife 161

The Kiss 173

The Man and Wife Sarcophagus 35

The prodigal Son 171

The Rebellious Slave 121

The Saint Wifes at the Tomb 101

The Thinker 159

The Thought 169

The Virgin between Saint Francis and Saint Anthony, main altar 97

The Walking Man 189

The Wood 231

Three Standing Figures 225

Torso of Adèle 163

Tribute procession of the Medes 23

Two Discus Throwers 43

V

Venus of Melos 65

Victor Hugo 165

Victory 129

Victory Fastening her sandal 49

Virgin at Stairs 107

Virgin with a Child 91

Votive Statue of Gudea 15

W

West Pediment of Zeus Temple in Olympia,

centaur raping Déidamia 41

X

Xenobia in Chains 155

Z

Zeus and Ganymede 39